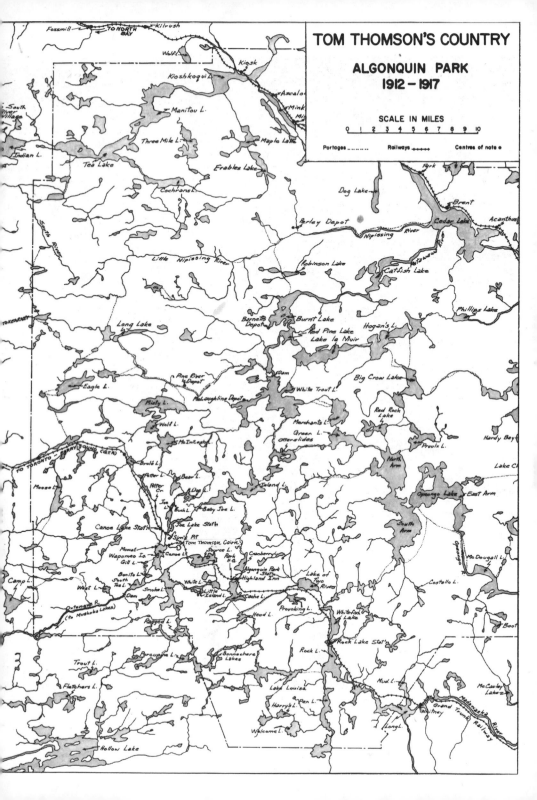

TOM THOMSON'S COUNTRY

ALGONQUIN PARK
1912 – 1917

SCALE IN MILES

0 1 2 3 4 5 6 7 8 9 10

Portages Railways ++++ Centres of note •

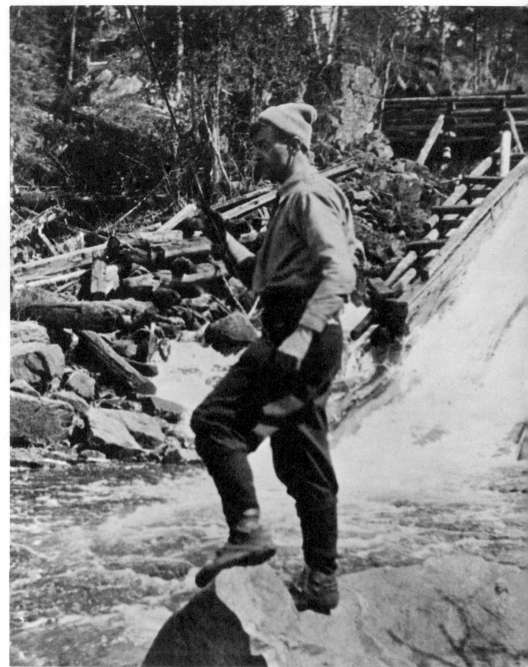

TOM THOMSON
The Algonquin Years

OTTELYN ADDISON

in collaboration with

ELIZABETH HARWOOD

with

Drawings and an Appendix by

THOREAU MACDONALD

The Ryerson Press
TORONTO WINNIPEG VANCOUVER

Published 1969

Third Printing, 1970

ISBN 0-7700-0300-1

PRINTED AND BOUND IN CANADA
BY THE RYERSON PRESS, TORONTO

JACKET PAINTING
Tea Lake Dam, 1915, Oil, 8½″ x 10½″
THE NATIONAL GALLERY OF CANADA, OTTAWA

NOTE

Almost all of Tom Thomson's work was done in Algonquin Park during the four or five years that preceded his death in July, 1917. His paintings are a record of the trees, rocks, rivers, lakes, skies, winds and weather of Algonquin of that period.

A passion for the wilderness dominated Thomson's painting and his life. Accuracy, vividness and an exuberant joy in nature are qualities that characterize his sketches and give them lasting appeal.

It is the purpose of this account to make readers more familiar with the circumstances of Thomson's life during his Algonquin years and to help them visualize his surroundings.

Those who have travelled the canoe routes and portages of the Park will find the map and references to specific lake areas of particular interest.

Photographs and other records are included in the hope of providing a clearer picture of the man and his times.

O.A.

Thomson's work would be a fine study for some competent critic, but anyone attempting it should be familiar, not only with every phase of his work, but with the country too. He must know the trees, rocks, lakes, rivers, weather; have them in his bones. ...

THOREAU MACDONALD

FOREWORD: BY A. Y. JACKSON

It is good to see a new book on my old friend Tom Thomson. His work seems as fresh today as when it was painted, over fifty years ago.

Thomson would have been over ninety now—I wonder how his style would have changed if he had lived. The work he did during his few years of painting provides a brilliant and memorable image of our country. His very first major landscape canvas "A Northern Lake," 1913 looks as if he had already been painting for ten years.

The present book will give its readers plenty of fresh factual material from those far-off days and form a good supplement to the all too few works on Thomson's life.

A. Y. Jackson

September 10, 1969.

ILLUSTRATIONS

Tom Thomson's Country: Algonquin Park i

Tom Thomson .. ii

Thomas ("Tam") Thomson; Elizabeth (Brodie) Thomson .. 2

John Thomson; Margaret (Matheson) Thomson 3

The house at Rose Hill Farm 3

Early Oil painting by Thomson 4

St. Thomas Anglican Church, St. Catharines (Watercolour) .. 5

Tom Thomson at age 16; at age 30 5

Watercolour by Arthur Lismer 7

Watercolour by H. B. Jackson 7

Grip Company in 1910 ... 7

Drowned Land (Oil) ... 8

A Northern Lake (Oil) ... 9

Mark Robinson, Ernest Thompson Seton, Stuart L. Thompson, Taylor Statten 10

Timber Chute (Oil) ... 11

Mowat Lodge .. 12

Canoe Lake Station ... 13

Shan Fraser and team ... 14

Tom Thomson at a campsite in 1912 15

Burnt Land (Oil) .. 17

Early shelter hut, and interior 18

Thomson with a day's catch 19

Portaging ... 20

Tying a fly ... 21

Rangers Mark Robinson and Jim Bartlett 23

Camp reflector oven ... 23

Ranger Tom Wattie ... 24

Stormy Evening (Oil) ... 26

Large beaver dam ... 29

Thunder Cloud (Oil) ... 31

J. Shannon Fraser; Mrs. J. S. (Annie) Fraser; Lumber camp "waterboy"; H. A. "Bud" Callighen 34

Veteran guide, George Rowe, with Charlie Scrim 37

ILLUSTRATIONS

Abandoned logging dam near Canoe Lake 37

Sketch by Thoreau MacDonald of man in a canoe 39

Spring Ice (Panel) .. 42

Spring Ice (Oil) .. 43

Inscription on Tom Thomson's cairn, Canoe Lake 45

Thomson's shack as remembered by Thoreau MacDonald 48

The shack as it is today .. 49

Frost-Laden Cedars, Big Cauchon Lake (Oil) 50

The Jack Pine (Oil) .. 54

The West Wind (Panel and Oil) 56

Dr. R. P. Little; Winifred Trainor; Canoe Lake berth 58

Setting off for Canoe Lake Station 61

Thomson's guide license .. 63

Pencilled caricature of Lieut. Robert Crombie 64

Northern Lights (Oil) .. 67

Mark Robinson and son Jack .. 68

Temporary death certificate; Letter of explanation
 regarding issue of certificates 72

Certificates issued by coroner 73

A note about Tom Thomson .. 74

COLOUR PLATES

Northern River .. facing page 26

Wildflowers .. ″ ″ 27

Timber Chute .. ″ ″ 27

The Lone Pine .. ″ ″ 42

Algonquin, October .. ″ ″ 43

PROLOGUE

Thomas John Thomson was born at Claremont, Ontario, on August 5th, 1877. His paternal grandparents emigrated from Aberdeenshire about 1833. Their only son, John, married Margaret Matheson, daughter of a pioneer family of Prince Edward Island, and Tom was the sixth of ten children. Two months after Tom's birth, his father decided to move to a farm at Leith near Owen Sound, Ontario, and it is there that he grew up.

The countryside along the shores of Georgian Bay could not fail to interest and inspire a growing boy, especially one of Tom's temperament. He spent a great deal of time out of doors, rabbit hunting, inspecting the maples at maple syrup time, swimming, and taking day-long fishing trips with his father and brothers.

Thomas ("Tam") Thomson, 1806-1875.
Elizabeth (Brodie) Thomson, 1812-1874.

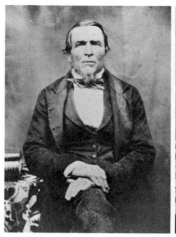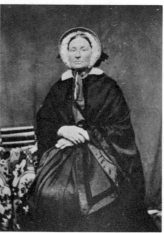

In his youth he had bouts of illness that interrupted his schooling and that may account for a later introspection and a quiet, reserved manner. Nevertheless, he seems to have grown up physically strong, tall and handsome. He was a capable fisherman, an amateur musician who played the mandolin and other instruments, a good companion and a lover of beauty in the natural scene.

The choice of a vocation did not come easily. He could not reconcile himself to the life of a farmer and at the age of twenty-one tried an apprenticeship in a machine shop in Owen Sound. Later he entered business college in Chatham but found the work uncongenial. Eventually, in 1901, he followed his older brothers to Seattle, Washington, where he became interested in photoengraving. This proved to be the most agreeable employment he had found and he stayed four years. While he was in Seattle he began to sketch in crayon and water colour. It is said that he fell in love during this period. In 1905, however, he returned to Toronto and began life as a letterman in a commercial art firm. He never married.

John Thomson, 1839-1930.
Margaret (Matheson) Thomson, 1843-1925.
The house at Rose Hill Farm near Leith, Ontario.

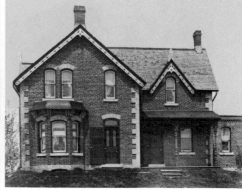

3

Thomson's skill in lettering and his eye for design guaranteed him a satisfactory income from work that he enjoyed. His love of music gave him an interest in concerts, particularly those of the Mendelssohn Choir in Toronto; his brother Fraser recalled his "whistling the tunes all the way home." He spent weekends in Owen Sound, bringing friends with him or joining with the family to hunt and fish. In Toronto he often visited a relative, Dr. William Brodie, who was a well-known naturalist. He occasionally helped Dr. Brodie gather specimens for his extensive collections. In 1907, it appears, he took a few art lessons from William Cruikshank who was well known as a drawing teacher.[1]

Early oil painting by Thomson, done presumably in the studio of William Cruikshank. His teacher's comment was his first real encouragement: "Did you paint this? Well, you'd better keep on." Oil, 1907. 10⅝" x 14⅝".

4

Tom at age 16

Tom at age 30

On a visit to St. Catharines in 1905, Thomson made a sketch of St. Thomas Anglican Church. He later presented the watercolour as a gift to a sister.
Watercolour, 1905-6. 11⅝" x 17½".

Thomson had dark brown eyes, a well shaped nose, and "fairly long, straight black hair; he had a habit of occasionally throwing it back from his forehead; this was done with an air of great freedom and grace." (I. R. MACKINTOSH)

About 1908 Thomson joined the staff of Grip Limited,[2] an engraving house in Toronto where Albert H. Robson was art director. This was a turning point in his life as well as his career. At this time, it has been said, the firm of Grip constituted "a sort of graphic arts university." Among Thomson's fellow workers over the next few years were J. E. H. Mac-Donald (senior designer), F. H. Varley, Franklin Carmichael, Arthur Lismer, William S. Broadhead, Frank (Franz) Johnston, T. W. McLean, H. B. Jackson, and others. Some of these men were European-trained; others had studied art in Canada. Some of them were later (in 1920) to become original

members of the Group of Seven. They liked Thomson's work and encouraged his efforts; their influence, especially that of J. E. H. MacDonald, was of great importance to his development. With his friends he made frequent fishing and sketching trips to places near Toronto and to Lake Scugog. The early small brown and grey sketches of Lake Scugog have been described as "honest and plodding."[3]

In 1910 Thomson made a trip to Huntsville to visit Dr. J. M. McRuer (He had been best man at Dr. McRuer's wedding at Brampton the year before) and did some sketching around Fairy Lake.

As far as can be learned, however, it was not until May, 1912, that Thomson first camped at Algonquin Park.[4] With H. B. (no relation to A. Y.) Jackson, he set up his tent at Tea Lake Dam and explored, fished and did some sketching in the surrounding country. He and Jackson had been told of the attractions of Algonquin by Tom McLean, another Grip artist; they took with them a letter from McLean to the Park Superintendent, G. W. Bartlett. Thomson's painting efforts during this trip were described by Jackson as limited to "a few notes, sky lines and colour effects." Partly as a result of Jackson's enthusiasm, however, his interest in landscape sketching began to grow.

Jackson painted a portrait of Thomson during this holiday. He described it later: "If it was a rainy day we would stay in camp. Tom would clean his pipes & read Walton's *Complete* (*sic*) *Angler*. It was one of those days I made the portrait sketch. Deer visited the camp every eve. Wolves could be heard in the distance. We were very much alone. I look back on that trip as one of my best vacations."

H. B. Jackson continues: "Tom was never understood by lots of people, was very quiet, modest. He cared nothing for social life, but, with one or two companions on a sketching & fishing trip, with his

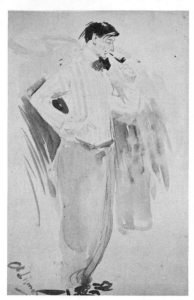
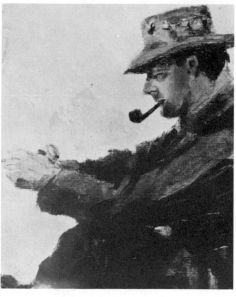

Watercolour, 8″ x 12″ by Arthur Lismer, 1912.
"In his city clothes he occasionally affected silk shirts of a fairly loud pattern and, such were the men's styles in his day, peg-top pants and 'horned' shoes." (A. LISMER)

Watercolour, 4¼″ x 5⅓″ by H. B. Jackson.
Copy of an oil sketch made in 1912, now in the National Gallery. Tom is wearing an old fedora loaned to him by his brother Fraser, for whom H. B. Jackson made this water-colour copy.

Grip Company in 1910: in foreground, Tom Thomson; behind him, Fergus Kyle; rear right, J. E. H. MacDonald; rear left, Albert H. Robson.

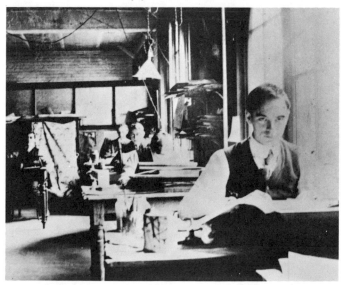

pipe & Hudson Bay Tobacco going, was a delightful companion. If a party or the boys got a little loud or rough Tom would get his sketching kit & wander off alone. At times he liked to be that way. Wanted to be by himself."[5]

Thomson appears to have stayed in Algonquin much of the summer.[6] In August, however, another artist and fellow-employee at Grip, William Broadhead, persuaded him to go on a sketching trip through the Mississagi Provincial Forest Reserve. They took the train to Biscotasing, paddled three hundred miles down the Mississagi and neighbouring lakes and rivers, and completed some sketches which were preserved in spite of an upset and drenching.[7]

Some of the salvaged sketches were seen by Dr. James MacCallum, Toronto oculist and friend of artists, who met Thomson for the first time in October, 1912. Dr. MacCallum's encouragement and financial support were to be invaluable in later years. From this time he began to buy Thomson's sketches; their purchase, Tom said, would help him "buy some more paint."[8]

Drowned Land. 1912. Oil, 6¾" x 9⅝".
"He brought back [from the Mississagi] a number of sketches. . . . One in particular of drowned land impressed me as having the weird loneliness of the country." (A. H. ROBSON)

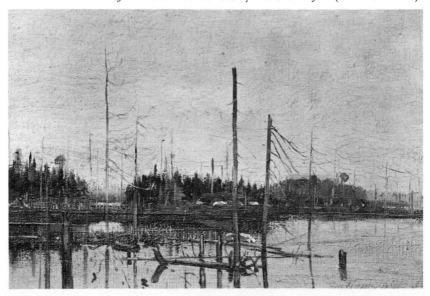

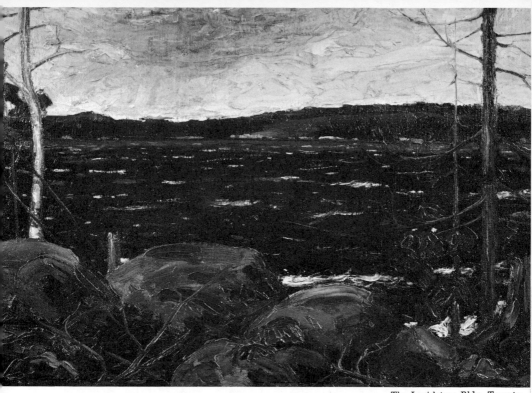

A Northern Lake, 1913. Oil, 30″ x 36″.

Back at work in Toronto in the winter of 1912-13, Thomson completed a canvas from a sketch made the previous summer. Entitled "A Northern Lake" it was exhibited by the Ontario Society of Artists early in 1913 and, to Thomson's surprise, selected for purchase by the Provincial Government at a price of $250.[9] He cashed the cheque in one-dollar bills, took them home, threw them into the air and, said Arthur Lismer, "danced a fandango". It was his first success.

In May he left the firm of Rous and Mann to which he had transferred the previous October. He packed his gear for another summer of camping, fishing and sketching, and took the train for Canoe Lake. The years of preparation were over; the Algonquin years had begun.

9

THE ALGONQUIN YEARS

The area of Algonquin Park was set aside as a provincial game preserve in 1893.[10] Unsuited to farming, the land had remained largely a wilderness, although its wildlife had been depleted by hunters and trappers. Pine timber had been cut in the area for fifty years or more. Logging companies built roads for winter use and left clearings, log chutes and dams scattered over a wide territory.

A peninsula on the northwest shore of Canoe Lake was originally chosen as the site for Park headquarters. The choice was a logical one as this lake commanded the main approach to the extensive chain of waters lying north and east. Other considerations favouring the site were an existing lumber road that ran from Dorset to South Tea Lake (where a main supply depot was located), and the projected route of a railway line to be built from Ottawa through Arnprior to Parry Sound.

On the same peninsula, a few months later in 1893, Gilmour Lumber Company built a large mill. Buildings to house staff and equipment were added and by 1896 the village of Mowat, with 600 inhabitants, had come into being. Three years later, however, the newly-constructed railroad line bypassed Canoe Lake, and Park headquarters were moved to Cache Lake.

L. TO R.: *Mark Robinson; Ernest Thompson Seton, author-lecturer; Stuart L. Thompson, writer-naturalist; Taylor Statten.* Photographed at Canoe Lake Station, 1922.

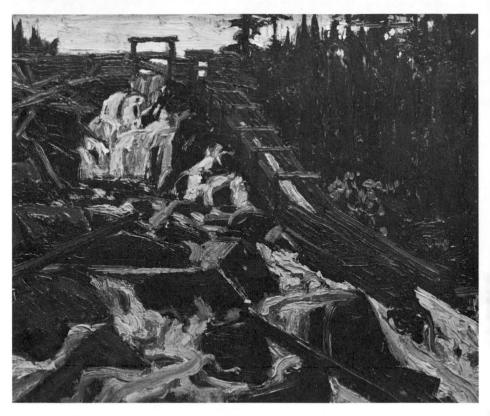

Timber Chute. 1915. Oil, 8½ x 10½".

The ambitious plans of Gilmour Company led it into bankruptcy, and Mowat shortly after became a ghost town.

Some fishing and camping parties entered the Park as early as 1894 and their numbers increased after the railroad was completed in 1899. To the general public, however, the Park's attractions remained little known and it was not until after 1912, when Joseph Adams published *Ten Thousand Miles through Canada*, that a trip to Algonquin became fashionable. Even then, the Park was "chiefly enjoyed by American visitors and a few eccentric artists and nature-lovers from Toronto."[11] One of the "eccentric artists" was Tom Thomson.

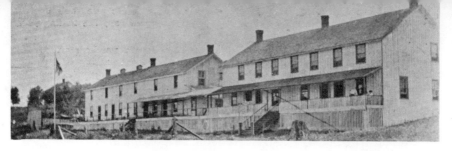

Mowat Lodge. In Thomson's time, only the building on the right was in year-round use. The Lodge burned down in 1920, was later rebuilt on a new site and remained in operation until 1930.

When Thomson arrived in the early spring of 1913, the Park was a quiet place. Lumbering had largely ceased in the southern section and the permanent inhabitants consisted of some railway maintenance men, a few lumberjacks and gravel pit workers, and the fifteen rangers employed by the Government to supervise the game preserve. A number of fishermen came in each year for the opening of the trout season and left again; a few cottagers and campers would arrive later along with guests for the summer hotels. There were no roads except the trails through the bush left by the logging operators along with the slash and debris of old logs already weathering away. The interior of the Park was for the most part a solitude of rock, bush and muskeg, accessible only by canoe and portage, and inhabited only by the wildlife it sheltered and sustained.

To many city-dwellers, the prospect of a long stay in such a wilderness would be depressing, if not terrifying. To Tom Thomson, ardent fisherman, enthusiastic canoeist and landscape painter, it was all that could be desired.

Mark Robinson,[12] a Park ranger, met all trains stopping at Canoe Lake Station as part of a routine check for fur poachers. He remembered meeting Thomson on his arrival the previous year, "a tall fine-looking young man with a packsack on his back" who asked for information about a place to stay. Robinson recommended Mowat Lodge.

Mowat Lodge (or Camp Mowat as it was earlier known) was originally the boarding-house belonging to Gilmour Lumber Company. J. Shannon Fraser, the proprietor, had come in to dismantle some of Gilmour's machinery and stayed on as postmaster. His kind-hearted wife, Annie, operated the Lodge, did the cooking and made her guests feel part of the family.

The Lodge building itself was unprepossessing. It was a two-storey, white-washed wooden structure, with a veranda across the front. Set on rising ground at some distance from the water, it faced the old mill yard, a treeless, desolate area of thirty acres or more covered with pine slabs and sawdust. Some abandoned buildings from former days were still standing—the horse barn, a storehouse, and a building which had served as the mill hospital. By the lake-shore stood the ruins of the mill itself and three houses in good repair which were occupied by summer residents. A small burying-ground lay a short distance from the Lodge; the railway station was about two miles north.

Canoe Lake Station came to life at train time.

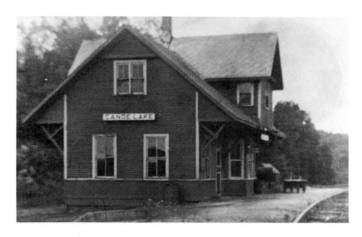

13

Shan Fraser and team, waiting for the train.

Although the Lodge was inadequately heated, and furnished in a makeshift manner, it offered good food and reasonable shelter at moderate rates. Wildlife was plentiful in the surrounding area; deer wandered across the chipyard, and beaver swam in the bay nearby. For as long as Tom Thomson returned to the Park, Mowat Lodge was his headquarters.

As soon as weather permitted, however, he would leave the Lodge to set up camp by himself. R. P. Little, who met him during his early days at the Park, described him as follows:

I first met Tom by the shore near Mowat Lodge. . . . Dressed like a woodsman in Mackenaw trousers . . . [he] was camped in a grove of birch trees situated on the north shore of Canoe Lake immediately opposite the old mill. . . . The ground had been dug up and some lumber was piled to one side. Tom was living in a tent amid his Hudson Bay blankets, panels, pots, and provisions (including a sack of flour). What a horse is to a cowboy, a sixteen-foot canvas-covered canoe was to Tom. . . . I asked him if I could camp with him. Tom said he had no objections but doubted if I would like the cooking as he lived largely on bacon, flapjacks, fish and potatoes. He suggested that I see the Frasers.[13]

14

Thomson was, in fact, too absorbed in his painting to be bothered with company. Mark Robinson's shelter house was located just above Joe Lake Dam on the shoreline across from Joe Lake railroad station. He frequently saw Thomson at work in the early days:

He got into the habit of coming up Joe Creek and getting up out of his canoe, walking up along that little piece of rapids that runs up from the bridge, and he would sit there and he'd throw stones into the water, look at the heavens and clouds, then look around and throw another stone.[14]

He spoke to Robinson of his difficulties in obtaining accuracy in certain colours. While his experience as a commercial artist had made him a good designer, he had had little formal training in art. The choice of subjects was not a problem; for him the Park abounded in things to paint. But he had still to develop a technique that would be adequate for his purpose. He set to work, studying the white birches and painting the alders at various stages of their spring growth.

Tom Thomson at a campsite in 1912.

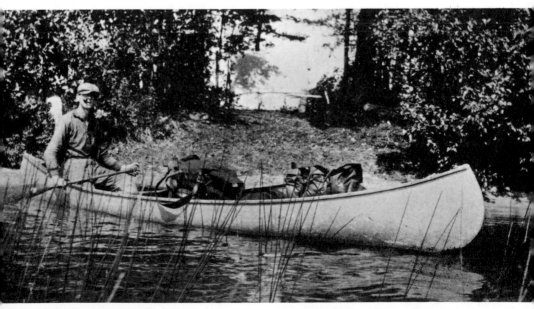

Thomson's restless energy is revealed in Robinson's account of a day when he painted an old pine rampike. He came in to the Robinson house one morning and paced up and down as he talked. "Where do I get it?" he asked, paying no attention to Mrs. Robinson or the children. "What is it, Tom?" asked Robinson. "I want to get a pine with the old branches coming out low down . . . the ugliest-looking old thing you know of, and bark on some of it—a dead pine." Robinson gave the matter some thought and remembered that up across March Hare Lake (east of Canoe Lake) and right in behind a former square timber camp, one of the Camboose type, there was an old, ugly-looking tree. He described it to Thomson, who rushed out without saying a word. Later that afternoon he came back, smiling, with the completed sketch and kind words for everyone.

As the season advanced, summer visitors began to arrive, some to fish while others sat on hotel verandas. The older hotels, built in 1906, were the Highland Inn on Cache Lake and the Hotel Algonquin on Joe Lake. Nominigan Lodge at Smoke Lake and Minnesing at Island Lake were constructed in 1912 and 1913. These hotels attracted vacationers from Ottawa and Toronto as well as many Americans. Among the guests each year would be a number of invalids who came to breathe the aromatic and invigorating air of the Algonquin woods. The more energetic visitors who liked to fish gave employment to the resident guides.

Thomson was not penniless and outside of sketch boards and paint his wants were few. Nevertheless, as summer began, he doubtless gave some thought to obtaining employment. Summer greens were not the most interesting subjects for painting. Any amount earned would help him to prolong his stay in the Park until the late fall.

16

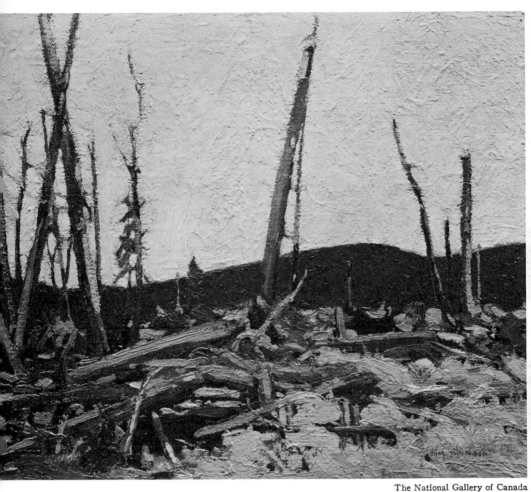

Burnt Land. Oil, 21½″ x 26″. 1916.

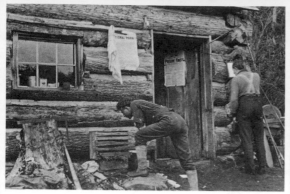

LEFT: *Type of shelter hut built in the period from 1895 to 1900. The huts were intended for the use of rangers travelling through the Park and were spaced a day's travel apart. Tourists were permitted to use them in case of bad weather or emergencies.* RIGHT: *Interior of shelter hut in 1908. Rangers George and Robinson relaxing.*

For someone like Thomson seeking casual employment, the common occupation was fire-ranging. Those who made the proper arrangements were appointed on a permanent basis for a full season; students occasionally earned their tuition fees in this way. Others were hired as temporary help whenever fires broke out.

Guiding, the other main source of summer income, was available to those who possessed the required skills. Thomson spoke to Robinson about the possibility of taking out a guide's license. While few, if any, detailed records are available, it is logical to assume that Thomson did a little guiding as well as some temporary fire-ranging in the summer of 1913.[15]

Since experienced guides were available, a newcomer would have to prove his abilities. A guide's main task, however, is to find fish for his party and in this Tom Thomson had had long experience. As a youngster he had learned to catch fish and cook them for his friends. "I can see him yet," wrote his sister, "as a small boy, with a string of tiny fish caught in the creek, which he would clean, then smoke in a link of stove-pipe, and I still remember how delicious they were."[16] With his father and brothers,

he had spent long hours on Georgian Bay bringing
in a supply of lake trout for the winter. In an eight-
een-foot rowboat they would start out early in the
morning for the shoals near Owen Sound. By eve-
ning, if the fish continued biting, John Thomson
would say, "Let's just have another row around."
The other boys would grumble but Tom never
seemed to mind.

Thomson was a fly fisherman of exceptional skill.
In the words of Tom Wattie, a Park ranger who
knew him well, he "could cast his line in a perfect
figure eight and have the fly land on the water at the
exact spot planned." He knew trout have to be down
in the cold water in summer; he looked for the rocky
shelves where they loiter; he studied their habits,
observed them feeding. He made his own lures from
bits of metal, feathers and beads, watched what the
fish were taking and painted his own "bugs."

*Thomson on his return from Westward Lake with a day's
catch; old mill buildings in background. 1912.*

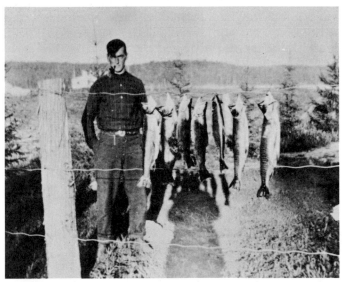

19

The contest with a wily old trout or bass delighted Thomson. The Mississagi area had not been to his liking. In a letter to Dr. McRuer regarding that trip he had written: "All the fishing there . . . is pike and they are so thick there is no fun in it."

Thomson was usually successful even where other anglers were not. But he had his failures too. At times he would go to some trouble to paint a new plug. The fish would survey his handiwork, swim on a little piece and survey it from another angle, then pass on. "Real artists," Thomson called them. "They saw all there was to see, then calmly swam away."[17]

Often he cast for speckled trout; at times he trolled for the lake trout that were common in the Park. At one period R. P. Little saw him nearly every day, trolling back and forth alone in his canoe. His reputation as a fisherman quickly grew. When A. Y. Jackson visited the Park early in 1914, he observed in a letter: "It appears that Tom Thomson is some fisherman. Quite noted round here."[18]

A guide must also be able to set up a tent quickly, rig a tump-line, handle an axe, build a campfire, and make his party comfortable under all circumstances. Such skills are not acquired overnight. In his early years at the Park Thomson often travelled with George Rowe,[19] a resident guide, easy-going but experienced and capable. Thomson could hoist a pack and canoe with no apparent effort and his skill as a guide became well known.

Portaging, Thomson (hidden by canoe) followed by fishing companion.

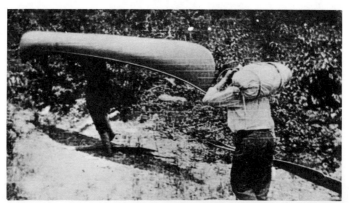

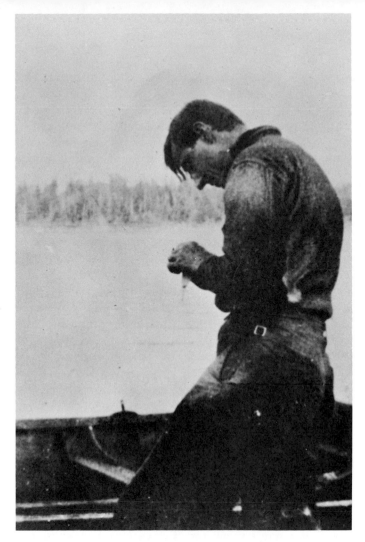

Tying a fly: Thomson in a characteristic pose.

From his youth he had been an excellent swimmer. The waters of Georgian Bay are particularly inviting and crystal-clear and Thomson swam a great deal in the summer evenings. In later years he was described by Mark Robinson as "capable of swimming the length of Canoe Lake easily." Robinson adds that there were many occasions at the Park when Thomson helped to save lives.

He was not, at the outset, an expert canoeist. His early experience had been confined to rowboats because his father distrusted canoes. At the start of an early fishing trip into Algonquin Park a strong southerly gale blew up. Thomson and a companion (presumably H. B. Jackson) loaded the canoe with dunnage but, when it came to pushing out in the storm, Shan Fraser realized Thomson was not familiar with canoes. He persuaded them to unload the canoe and stay all night at Mowat Lodge.[20]

In time, however, Thomson acquired an ease in paddling that enabled him to make long journeys alone. Using a short stroke that began at the waist and ended with a push from the shoulders, he could keep going all day with no sign of fatigue. His canoe was made by the Chestnut Canoe Company of New Brunswick. He painted it dove grey and Arthur Lismer recalled that once when the desired shade of enamel was not available, Thomson added some cobalt blue (at two dollars a tube) and considered the investment well worthwhile.

Thomson's love of canoeing is illustrated in a story told by J. E. H. MacDonald:

One day Tom came in to work carrying a new canoe paddle. He filled a photoengraver's tank with water and put it beside his chair, then without a word sat there gently paddling. At each stroke he gave the real canoeman's twist and his eye had a quiet gleam as if he saw the hills and shores of Canoe Lake.[21]

There are many accounts of Thomson's skill at camp cooking. His friend, H. B. Jackson, described him as a "real cook. . . . Our lake trout was boiled and baked, not fried. . . . Everything had to be cooked just so."[22] A reflector oven was standard equipment on a canoe trip. If Thomson stayed in camp a day or two, he might make a blueberry pie or some biscuits.

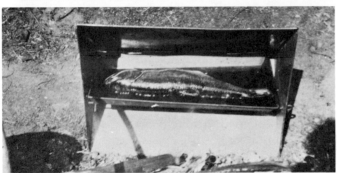

*Rangers Mark Robinson and Jim Bartlett (son of Park
Superintendent G. W. Bartlett).*

Camp reflector oven used by Thomson.

Flapjacks, bacon, beans, fish, onions, rice, bannock,
and tea were the mainstay of a woodsman's diet.
Strawberries, raspberries, blueberries and wild cran-
berries were abundant in the Park. A tin of jam or
some blackstrap molasses was the usual accompani-
ment to these foods; Thomson himself was fond of
maple syrup.

The hardships and hazards of such a life are obvious. Blackflies and mosquitoes were frequent annoyances. Cold nights and rainy days made for added discomfort. In a letter to Dr. MacCallum, Thomson once wrote: "We have had an awful lot of rain this summer and it has been to some extent disagreeable in the tent, even with a new one, the very least you get your blankets wet and if you spread them out to dry it is sure to rain again."[23] Portages forced the canoeist to travel light. As another painter and forest-traveller, Emily Carr, put it, "When you have to lug bed, blankets, food and painting gear and do it mostly yourself you go easy on luxuries."[24]

Toward the end of August, Thomson set out alone on a trip to the northwestern part of the Park. He paddled to Manitou and North Tea Lakes and introduced himself to Tom Wattie,[25] a ranger stationed in the area. The two men got along well together. Wattie said afterwards that no one could beat Thomson's partridge stew and dumplings; Thomson praised Wattie's tea and cornmeal cakes. Wattie expressed an interest in learning to paint but wound up with more paint on himself than on the sketch board and Thomson laughed uproariously.

On September 19th he was back at Canoe Lake. The maples were by now bright in their autumn colour and he made a number of sketches. Robinson remembered seeing him as he watched the movement of the waves on the lakes during storms and high wind. Cloud-filled skies and rough waters were to be frequent subjects for his study.

Earlier in the year he had mentioned to Robinson his difficulties in handling browns and greys. Robinson, a skilled naturalist, suggested that one of the ferns, *Osmunda regalis,* offered a good variety of rich browns after frost strikes it in the fall. He recalled that Thomson studied the plant during the late autumn.

Ranger Tom Wattie.

It was November before he packed up his sketches and returned to Toronto. On his way he stopped off at Huntsville to see his friend, Dr. McRuer. The latter's brother, J. C. (later Chief Justice) McRuer, met Thomson at the Dominion Hotel where he was staying and was shown a group of thirty sketches or so. Thomson confessed that he was worried about the possible reaction of his painter friends to some of the bright colour he had used; they might make fun of him, he said.

In Toronto an important event awaited him. At the invitation of Lawren Harris, A. Y. Jackson had come to that city. Jackson had studied in Europe and his encouragement and help were to be of inestimable value to Thomson. Jackson and he became firm friends and they shared a studio, the first to be completed in the new Studio Building erected by Harris and MacCallum, from January, 1914, until the following autumn.

A. Y. Jackson described his early conversations with Thomson:

We had much to talk about; he would tell me about canoe trips, wild life, fishing, things about which I knew nothing. In turn I would talk to him of Europe, the art schools, famous paintings I had seen and the Impressionist school which I admired. . . . He had an intuitive appreciation of what was good in painting, but apart from what was being done in Canada, there were few examples of the work of contemporary artists to be seen.[26]

The art that was popularly admired in Canada at the time was the "cow and windmill" school of Dutch painting, studies of Scottish mists or gentle English landscapes. However, the dream of a truly Canadian School of painting was already in the minds of such men as J. E. H. MacDonald, Harris, Lismer and Jackson. Thomson, in his own way, was to contribute immeasurably toward its fulfilment.

25

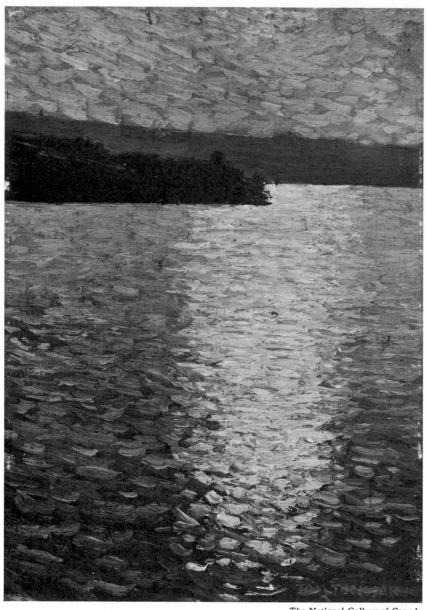

Stormy Evening. 1912-13. Oil, 10″ x 6⅞″.

26

Northern River, 45″ x 40″. 1915.

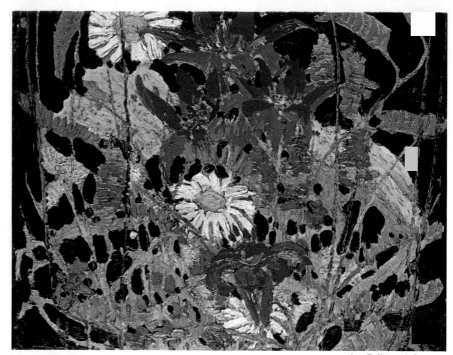

Flowers, 8⅜″ x 10½″.

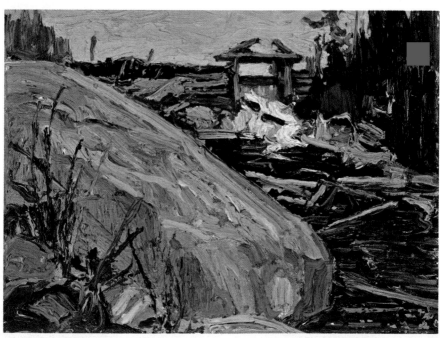

Timber Chute, 8½″ x 10½″. 1916.

At about this time (winter of 1913-14) Dr. James MacCallum offered to guarantee Thomson's expenses if he would devote a year to painting. A. Y. Jackson had already accepted a similar offer. Thomson reluctantly (because he doubted his own abilities) agreed and from this time he became a full-time painter, divorced from the commercial field. The fact that he would have no more than enough money for bare expenses does not appear to have affected his decision. His general philosophy seems to be expressed in a quotation from Kipling which he had earlier lettered in a pen-and-ink drawing: "I must do my own work and live my own way because I am responsible for both."

Many tales have been told of Thomson's indifference to money. His generosity toward friends and acquaintances was well known and he gave away many paintings which he might have sold. In the Park, he sometimes tied a roll of small bills to the thwart of his canoe; this was the safest way to carry money while travelling. In a less careful mood, however, he might stuff the money into a trouser pocket. Once when he pulled out a dollar bill along with a handkerchief, it dropped into the water. Rather than interrupt his trolling, he let it drift downstream.

At times he spent money with a free hand. When he needed paint, however, it was a different story. "What used to amuse me," wrote Mark Robinson, "was the way Tom could save the dollars when he wanted the oils, etc. for some scene he had been dreaming about. At those times he was absolutely stingy with himself and everyone else."[27]

Early in 1914 Thomson prepared two canvases for exhibition by the O.S.A., "Morning Cloud" and "Moonlight, Early Evening." The latter painting was purchased by the National Gallery later the same year.

Inspired by the accounts he had heard of Algonquin, A. Y. Jackson made a visit to the Park in February and March, 1914. The weather was severely cold and his work was hampered by temperatures that dropped to forty-five degrees below zero. From Mowat Lodge he wrote to J. E. H. MacDonald: "They have a gramophone here, the only really objectionable feature 'comic records'."[28]

J. E. H. MacDonald and J. W. Beatty went up to the Park in March. Thomson stayed in Toronto to finish some work; he was never at Algonquin with MacDonald. Arthur Lismer also went up to the Park to paint and in early May he and Thomson set up a main camp on Molly's Island in Smoke Lake. For three weeks they toured with pup tent and canoe through Smoke, Ragged, Wolf and Crown Lakes.

From Lismer come tales of Thomson's affinity for the woods, his remarkable powers of observation, his understanding of wild animals and knowledge of their habits. "The bush is a place where one gets to know a man," wrote Lismer. "One also learns a lot about one's own inadequacies. Thomson came to life in the bush.... He saw a thousand things—animals and birds, and signs along the trail that others missed."[29]

Thomson did not paint wildlife except for the nocturne "Moose at Night" and an occasional deer included in a larger scene. Moose and deer were numerous in Algonquin Park and he would have many opportunities to observe them closely. Bears frequently made their way along the old timber trails; Thomson humorously spoke of picking raspberries with a bear on one side of a log while he stood on the other. Chipmunks and wood mice would be attracted to his tent; porcupines also were a familiar sight. At the water's edge he would see beaver, mink, weasel and otter. On rare occasions a lynx might be glimpsed. The howl of wolves echoed across the marshes at night.

As an experienced woodsman, Thomson would know that he had no reason to fear animals if he treated them with respect. If he heard an unexpected sound at night, he would be able to account for it: a porcupine often sounds like a baby crying and if annoyed by some other animal can sound like a pack of demons; the sound of the wood-boring beetle gnawing outside a tent in the darkness takes on enormous proportions; a deer, stomping around snorting, can sound like an elephant.

Thomson had some favourite animal stories. A large timber wolf once came up quite close to him, then casually sauntered off. He was reluctant to recount this to his city friends; nobody believed him. One day he watched a bear climb a tall dead tree, look around for a while, then suddenly drop down to the ground and take off, sending the bark flying in every direction. Thomson laughed as he told the story, making the bear and his pressing engagement seem very human.

Large beaver dam in 1910: G. W. Bartlett stands on top to show height of construction.

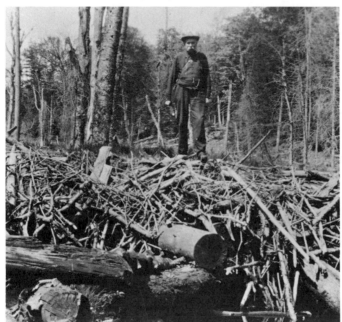

When asked if he were never lonely, Thomson once said: "How could I be? There is something happening every minute." As he paddled silently through the Park, something exciting or interesting would be waiting around every bend. Perhaps it would be a fawn with its mother, or a moose lifting its dripping head from the water, bunches of water-lily plants dangling from its jaws, a beaver swimming from house to shore, or a blue heron, stretching up its neck the better to see while walking sedately along a marshy inlet. He would hear the white-throated sparrow's notes at dawn, the all-day song of the winter wren, the varied calls of the loons and, in the evening, the flute-like phrases of the hermit thrush. The lively gray jay or "whiskey-jack" would be a companion at his campsite.

As he travelled, he absorbed all the sights and sounds of the Park and accumulated a host of impressions. When he was ready to set them down in a sketch, he did so with extraordinary rapidity, accuracy and vividness.[30] The difficulties he had experienced during his first days at the Park disappeared in long months of practice and experiment. The techniques he evolved were largely his own, born of the necessities of the scene before him. Dr. Mac-Callum described his working methods:

His idea seemed to be that the way to learn to paint was to paint. . . . He was not concerned with any special technique, any particular mode of application of colour, with this kind of brush stroke or that. If it were true to nature, the technique might be anything.[31]

Progress came in spite of a basic disbelief in himself that had hampered him in his earlier years of painting. His first efforts, dating from 1905 or so, show a timidity and a willingness to imitate which he

Thunder Cloud. 1912. Oil, 7″ x 10″.

later discarded. During the years at Grip Company he continued to paint and to learn, encouraged by the men who were his associates there.

His brother Fraser told a story of a day in 1910 when he and Tom visited an art exhibition in Toronto. Fraser called Tom's attention to a landscape he admired. Tom studied it a few moments, then said, "I don't like it." "Why?" asked Fraser. Tom replied, "How far away do you think the artist was when he painted that landscape?" "Possibly thirty feet," replied Fraser. "Well," said Tom, "how would the artist be able to see the veins in the leaves and other intricate details at that distance? That picture is almost outdated now and will definitely be outdated in a few years. An artist has to paint as he sees the scene if it is going to be natural and to last."

As Thomson matured as a painter, he developed the ability to summarize boldly, creating as he did so a strongly personal style.

31

He found subjects for painting everywhere. Wind-churned water against a darkening sky, a clump of sunlit birches, an old log flume or a handful of wild-flowers—any of these could inspire a fine sketch. The desolate areas of the north, drowned land and burnt-over country, seemed to fascinate him. He recorded impartially the changing moods of nature —sullen, angry, or "gloriously golden".

The effect of his work was to lead other painters for the first time to consider seriously the Canadian north woods as an aesthetic subject. Almost anyone who saw his sketches viewed the northland with new eyes. An acquaintance, Ernest Freure, who met and conversed with Thomson in 1914, said in later years: "I have seen beauty in the bare and broken branches of dead trees ever since."[32]

In the summer of 1914 Thomson paid a visit to Georgian Bay where Dr. MacCallum had a summer home. He travelled to Lake Nipissing via South River by lake, stream and portage, crossed the lake and paddled down the French River. Although he did a number of sketches at this time, he found much of the country inland monotonously flat and the rapids ordinary. In August he returned to Algonquin Park.

When the leaves began to change in September, several friends made visits to Algonquin—Beatty, Varley, Jackson and Lismer. In the words of R. P. Little, "the woods seemed full of artists." The maples were even brighter than in 1913 and there was much to see. The Park was not unknown to painters: as early as 1902 W. W. Alexander, David Thomson, and Robert Holmes had explored the area; they were followed by Tom McLean, J. W. Beatty and others. But for a period beginning in 1914 Algonquin Park held a unique place in Canadian art and the painters who worked there became known briefly as "The Canadian Algonquin School".

A. Y. Jackson joined Thomson in the autumn of 1914 and they travelled together, Jackson sitting in the canoe keeping an eye out for possible subjects while Thomson paddled. They worked on small birch panels 8½ x 10½ inches in size. Anything larger would be cumbersome; they worked up canvases in the studio later from the sketches they had made.

On October 5th Jackson wrote to J. E. H. Mac-Donald: "Tom is doing some exciting stuff. He keeps one up to time. Very often I have to figure if I am leading or following. He plasters on the paint and gets fine quality." Jackson adds: "But there is danger in wandering too far down that road."[33] It has been said that Jackson's criticism was just: Thomson sometimes did go too far in that direction.

Letters addressed to Dr. MacCallum reveal the enthusiasm of the painters as they worked together that autumn. "The country is a revelation to me," wrote Varley, "and completely bowled me over at first." Lismer reported: "Thomson and Jackson are camped just opposite Frasers and both are doing fine work and each having a decided influence on the other."

On October 13th A. Y. Jackson wrote Mac-Callum:

Varley Lismer and company are enjoying themselves thoroughly. out all the time. and the weather has been glorious. in fact they have had as much good weather in the last twelve days as Tom and I have had in a month. . . . Tom is doing some good work. very different from his last year's stuff. he shows decided cubistical tendencies and I may have to use a restraining influence on him yet. What he does to those poor fish when he isn't sketching is too awful to relate. Just now it is quite understood that the fish are not biting, a particular reason for him to want to catch them.

33

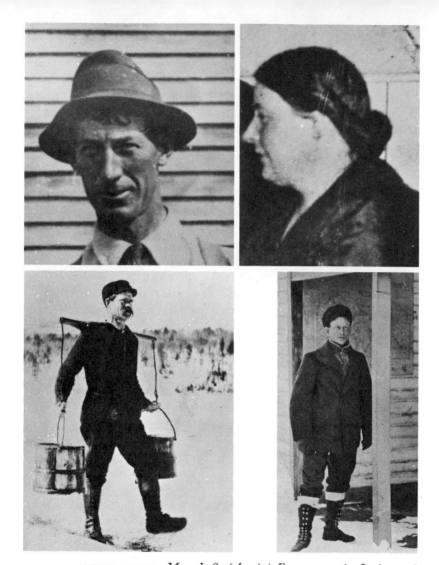

UPPER RIGHT: *Mrs. J. S. (Annie) Fraser ran the Lodge and did her best to make her guests comfortable.*
UPPER LEFT: *J. Shannon Fraser "as I recall always wore a blue suit on all occasions—always wore a tie—a fedora on the back of his head with a great shock of red hair projecting out in front. He was a tall man well spoken: loved to be the centre of attraction."* (J. A. COUTTS)

LEFT: *Lumber camp "water-boy."*
RIGHT: *H. A. "Bud" Callighen, Ranger at Smoke Lake, 1913.*

Thomson also wrote MacCallum:

I received your letter this morning and also your messages from Lismer. About the sketch if I could get 10 or $15 for it I should be greatly pleased but if they don't care to put in so much let it go for what they will give. . . . Jackson & myself have been making quite a few sketches lately and I will send a bunch down with Lismer when he goes back. He & Varley are greatly taken with the look of things here just now. The maples are about all stripped of leaves now but the birches are very rich in colour. We are all working away but the best I can do does not do the place much justice in the way of beauty.[34]

Thomson's self-disparagement is characteristic. His friends record that he was often frustrated in his work and had moments of deep discouragement. Once, in disgust, he threw his sketch box off into the woods. Jackson helped him find it and took it to H. A. "Bud" Callighen, a Park ranger, for repair.

At the end of his letter to MacCallum, Thomson adds:

I thought of putting in my application for a park Ranger's job and went down to Headquarters with that idea but there is so much red tape about it that I might not get on for months so I will try and get work in some Engraving shop for a few months this winter. . . . Remember me to Mrs. MacCallum the children and all the kind people that I met at Go Home.

The year guaranteed by MacCallum was coming to an end. A Park ranger's job would solve many of his problems but Thomson's dislike of "red tape" made him reject the idea. He had little patience with administrative detail and the use of petty authority annoyed him greatly. The story is often told of a day

35

when he tore up a cheque in a Toronto bank because the teller would not cash it without someone to identify him. "He knew that the teller knew who he was and he resented the red tape," wrote his sister Louise.[35] The story often ends with Thomson throwing the pieces of the cheque in the teller's face. This sort of action is not at all characteristic of Thomson, said J. E. H. MacDonald in a comment about the story. It is much more likely that, disgusted, he merely dropped them on the floor.

When Thomson arrived in Toronto in November, 1914, a notice appeared in the *Globe* under the "Arts and Artists" column:

Mr. Tom Thomson has just returned from a sketching trip in Algonquin Park, where he had gone to follow the autumn colour into winter. He brought back a great many fine studies, particularly remarkable for colour and originality of design, and the subjects range from studies of full autumn colour right through the fall of the leaf to white frosts and deep snows.

By this time the war looked more serious than it had at its outbreak in August. Jackson left for Montreal to join the army. Franklin Carmichael moved into the studio in Jackson's place. Thomson spent the winter making canvases from the previous season's sketching. "Northern River" was prepared from a sketch done in tempera and sent to the 43rd O.S.A. exhibition held in Toronto March 13 to April 10. Purchased by the National Gallery in May, 1915, it eventually became famous as a study of the remote, silent, mysterious areas of Algonquin Park.

Reports conflict as to Thomson's attitude toward enlistment. Mark Robinson, who served overseas from 1915 until early in 1917, said that Thomson tried to enlist more than once but was turned down.

Members of Thomson's family confirm that he tried to enlist but was rejected because of trouble with his feet. He had broken a toe during a football game in his youth and he had faulty arches. Thomson was provoked at the medical decision because he could walk twenty miles without discomfort.

Other friends (Dr. A. D. A. Mason, for example) believed that Thomson never tried to enlist and there seems to be little doubt that he gave that impression. He detested war; in a conversation with a sister he stated that he would willingly serve as an ambulance man but could not face the prospect of killing.

Robinson was wounded and returned from overseas early in 1917. He spent long hours in conversation with Thomson and knew him very well. Given the temper of the times, it is inconceivable that Robinson could have retained the respect and admiration that he always showed for the artist if he had had any doubt whatever about his attempts at enlistment.

Veteran guide George Rowe with Charlie Scrim holding lake trout (19½ lbs.). LEFT: *Abandoned logging dam near Canoe Lake about 1912.*

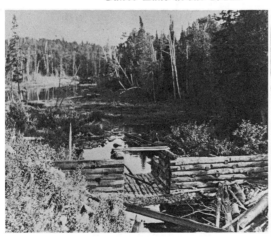

Early in 1915 Thomson was back at Canoe Lake. His friends in Toronto would sense his restlessness long before the winter's end. The urge to go north in spring, which in Thomson's case amounted to a passion, is a common experience for those who know the northland well. In addition to the delicacy of colour, there is a scent in the air combined of the tangy perfume of the balsam fir, the essence from the breaking buds and early blossoms, the rich earthy smells of the marshy bogs. It can be irresistibly attractive.

While the weather remained cold, Thomson stayed at Mowat Lodge. The wife of a railway employee at Canoe Lake Station recalled seeing him at about this time: "In the winter I would see more of him. [He] used to go up the track back of the section house [to] an old dam on Potter Creek: when the ice was breaking up, he used to paint there, come back to the Station and wait for Mr. Fraser to come for the mail." She added: "moody kind of a chap. I never heard him laugh: Never had much to say . . ."[36]

Other Park acquaintances confirmed this description of Thomson as moody and uncommunicative. His sister, Minnie, described him differently:

One opinion which seems to be held by most of Tom's later friends is that he was unusually reserved and quiet. I can't somehow reconcile that description of him with the Tom we all knew and loved at home. He had his quiet moods but one never caught his glance but he would smile. With his ain folk he was not reserved and silent. He dearly loved an argument and generally held his own in a battle of wits. His frequent visits home were always occasions of excitement and rejoicing especially among the children of the older members of the family by whom he was greatly loved. I have a happy memory of him sitting in a big arm chair painting prowling and very

ferocious looking tigers just ready to spring out of a tangle of jungle grass, while two of my sister's children perched on the arms of the chair and one peered over his shoulder, thrilled and spellbound. He used to enjoy dancing among the old crowd at Leith and Annan, and if possible would make a special trip home to attend a dance in the old hall.[37]

Mark Robinson related Thomson's appearance of moodiness to his erratic working habits. He did not paint as a regular routine; for days his brush and palette might lie unused. When he felt ready to work again, he would paint as if life itself depended upon speed. In a letter to Blodwen Davies written in March, 1930, Robinson described Thomson as "jovial at certain times," at other times "quite melancholy and dejected in manner." In the latter periods he would "suddenly as it were awaken and be almost angry in appearance and action. It was at those times he did his best work."

Franklin Carmichael said later that the winter of 1914-15 had been a particularly trying one for Thomson. Some of his friends had moved away, and the painters who remained were older men with whom he had less in common. He was upset about the war and its probable effects. His sketches sold only occasionally and he was wondering if he would be able to finance himself in future.

It is probable too that on his arrival back at the Park he was genuinely lonely. For a season or two in 1914 he had had the company of lively, stimulating friends who understood his work. Now he was on his own again.

He wrote Dr. MacCallum from the Park on April 22:

I stayed at Owen Sound for a week and made a few sketches and had to go back to Toronto to make connections for the Park. Stayed in Huntsville for two days and have been here since then

The snow in the woods here was about two or three feet deep when I got here and disappeared gradually until now it is gone excepting spots in the thick swamps

The ice is still on the lakes but it is getting pretty rotten and will break up the first good wind, so I will soon be camping again.

Have made quite a lot of sketches (about 25) some of them might do for canvases but will not pick out any until something better turns up. . . . I hear that my swamp picture [*Northern River*] is down at Ottawa on appro. Hope they keep it.

His favourite campsite at Canoe Lake was back of Hayhurst Point, immediately below the hilltop where his memorial cairn now stands. There his red, four-point Hudson Bay blankets would provide a splash of colour when strung out behind his tent. It was from this point that "Spring Ice" was sketched. Thomson, said Lismer, could "smell the colour of ice." The deep blues and greens of the water combined with the delicacy of opening buds in spring were the subject of several sketches.

On April 27th Thomson took out his guide license and left with a fishing party the following day. On May 10, 1915, Mark Robinson's Journal notes: "Geo. Rowe and Tom Thompson came in with the Johnston Bros. of Pittsburg, Pa. from trip through Park. They report lots of fish and fine time." A further note, dated June 28, 1915, states: "Tom thompson (*sic*) caught a 4½ Bass in Canoe Lake this morning."

At the end of July, Thomson wrote to J. E. H. MacDonald:

Thanks for sending on my mail and for your letter.

Things are very quiet around the Park this summer. have so far had only 2 or 3 weeks work and prospects are not very bright as the people are not coming in as they were expected. Of course there are a few jobs but there are more guides than jobs

I have made quite a few sketches this summer but lately have not been doing much and have a notion of starting out on a long hike and will likely wind up somewhere around the French River and go up the shore to Bruce Mines and later on may take in the Harvest Excursion and work at the wheat for a month or two

As with yourself I can't get used to the idea of Jackson being in the machine and it is rotton that in this socalled civilized age that such things can exist but since this war has started it will have to go on until one side wins out. and of course there is no doubt which side it will be. and we will see Jackson back on the job once more. . . .

Remember me to Lismer and tell him that I will expect him to be up here in the fall for a month or so. If I go out west I will be back about the end of Sept. and will camp from then until about November.

Regards to Mrs MacDonald & Thoreau also to Lawren, Heming & Williamson.[38]

While Thomson speaks in this letter of travelling north or west, sketches of the Georgian Bay area, presumed to date from this period, are evidence that he travelled in that direction. "Split Rock," "Pine Islands" and "Byng Inlet" belong to his Georgian Bay studies.[39]

T. W. Kidd, an art teacher at Riverdale Collegiate, Toronto, met Thomson, possibly in August 1915, and gave this account:

41

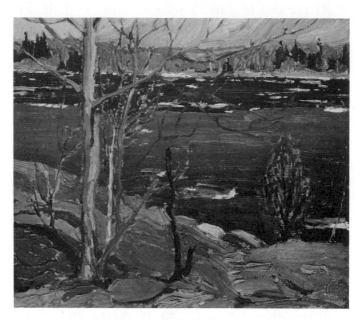

Spring Ice. c. Panel, 8½″ x 10½″.

I was walking along the street in South River carrying my water-colour outfit when someone called out to me. "You needn't think that you are the only artist here." "How's that?" "Tom Thomson is in town—I saw his canoe on the bank of the river."

I found him in a dark corner of Ard's store having his lunch, largely of boloney sausage, biscuits and a bottle of pop. Trying to get into conversation with him I enquired why he liked to come to South River when there were so many shopping centres much closer to his headquarters at Cedar Lake—Dorset, Bracebridge, Huntsville, Novar, Burks Falls, Sundridge. "Not by canoe" was all he answered. What a lot of information, I thought, was in that brief reply, for although it might easily have been three times as far as to some other villages, the distance was all by water routes, with easy portages and good fishing.

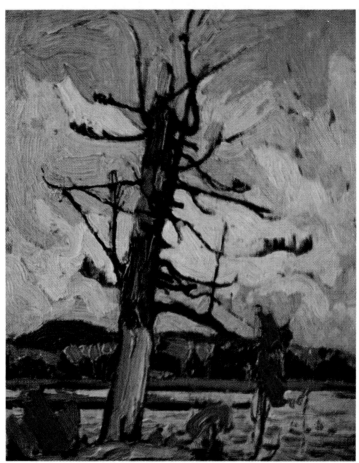

The Lone Pine, 10½″ x 8½″.

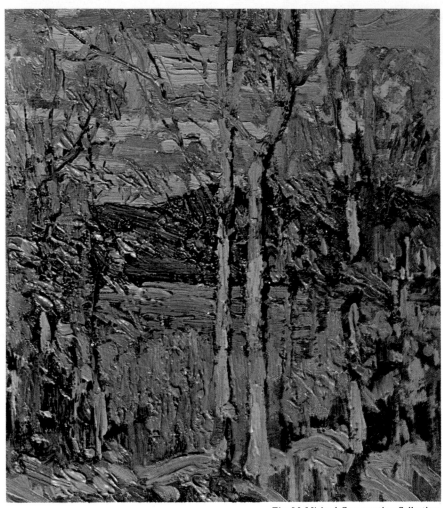

Algonquin, October, 10½″ x 8½″. 1915.

(Reproduction courtesy Ontario Department of Lands and Forests.)

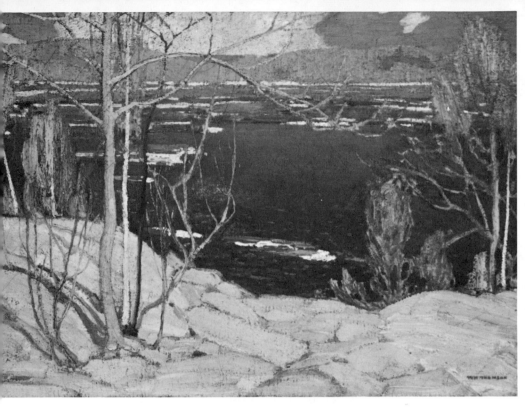

Spring Ice. 1916. Oil, 27¾" x 39¾".

He assured me also that he liked to get his supplies here where there was a veneer mill. I had already noticed that there were piles of birch panels about 8 x 10 already for him.

He liked to meet his old pals the forest rangers who lived in South River. They often brought out to him supplies and the mail. I asked him about the water-falls at South River for I had found them full of interest, but he merely shook his head.[40]

On September 8th Thomson wrote to Dr. MacCallum from the new Queen's Hotel in South River. He had been waiting impatiently for funds to be forwarded from a bank in Toronto. The twenty-five dollars he needed, to cover the cost of "stocking up" again, had not been received and he was afraid his

account had "gone broke". (Payment of $500 for "Northern River" had been forwarded from the National Gallery to the secretary of the O.S.A. but Thomson was apparently not aware whether this amount had been deposited to his account.) He added: "Have travelled over a great deal of country this summer, and have done very few sketches, it will be about a hundred so far."

The following day he had heard from the bank and wrote MacCallum again:

My letter from the Bank came last night after I had posted yours so I will get on the trail again this morning will go back up South River and cross into Tea Lake and down as far as Cuchon [Cauchon] and may make it out to Mattawa but it's fine country up this river about 10 miles, so there is lots to do without travelling very far.
There are stretches of the country around here that is a good deal like that near Sudbury mostly Burnt over like some of my sketches up the Magnittewan River, of running the logs. . . .
If Lismer or any of the boys can come get them to write me at South River. I should like awfully well to have some company.
P.S. One of the Park Rangers comes out here quite often & will take my mail in to me so I could come out here & meet any one at any time.

At some time during his summer travels, it is believed, Thomson met Archie Belaney, or Grey Owl, who gained fame by his books on northern wildlife. Interviewed twenty years later, Grey Owl remembered Thomson as a "ranger" who painted a little and made specially good doughnuts. Thomson had given him three sketches which he later hung on the walls of Beaver Lodge. Albert Robson, who knew both men, commented on the similarities in their appearance. They were about the same size and build.[41]

When Thomson returned to Canoe Lake, he brought a number of sketches. One that Mark Robinson remembered showed "the high colour of the blueberries: they get a brilliant [red] colour, even more so than the maples when the frost comes." Thomson studied the tamaracks which turn gold as winter approaches. "Spruce and Tamarack" transports the viewer right into the middle of a muskeg swamp with the ragged black spruce in the background, tamaracks and dead rampikes in the foreground. A fine sketch from this period, "Bateaux," shows the lumberman's pointers that were a familiar sight in the Park at anchor under a clear northern sky.

Inscription on Tom Thomson's cairn, Canoe Lake.

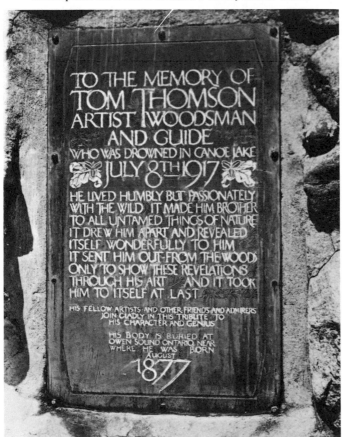

A snapshot believed to have been taken in the fall of 1915 (October?) shows Tom Thomson with Dr. MacCallum and J. E. H. MacDonald on the shore of Go Home Bay. It is possible that Arthur Lismer also was present as they took measurements and discussed plans for some decorative panels to be designed for the walls of MacCallum's cottage.

In November of 1915 Thomson was at Round Lake (now known as Lake Kawawaymog) with his friend Tom Wattie. He took the train to South River and completed the trip by horse and wagon over corduroy road. While Wattie and Dr. R. Mc-Comb of South River hunted deer, he remained at an island camp and painted.

The broad view and wide horizon visible from this island camp may have been factors in his choice of the site. It appears to have been an active period; "that tent was half full of his sketches when we broke camp," said the doctor later.[42] Thomson kept a few, gave some to Wattie and the doctor, and asked Wattie to burn the rest. The sketch boards made a brilliantly-coloured bonfire.

The Watties remember "Chill November" with its flight of wild geese silhouetted against a sombre sky as being one of the sketches done at this island camp. At the same period, Thomson completed a sketch, "Sand Hill". On the back of this sketch, painted after a rain, there is the following note: "On the day this was painted Thomson tramped 14 miles carrying sketch box, gun, a fox and 7 partridge which he had shot that day. As well as this sketch, he painted another." The location was somewhere on the road to South River, outside the boundaries of Algonquin Park.

Thomson seems to have felt at home with the Watties and their children, and they greatly admired him. A sketch of the campsite retained by the family was inscribed by a young daughter: "Round Lake,

November 1915. Painted by Tom Thomson, the world's greatest artist." The Watties also recalled that Thomson occasionally attended square dances at South River, inviting as partner a young lady who worked at the local post office.

When Tom Thomson returned to Toronto, it was to the shack behind the Studio Building, later to be known as "Thomson's Shack." Here he painted canvases from sketches made the previous season; here, too, he could live for next to nothing in a fashion that suited his woodsman's habits.

The old building on Studio Building property had fallen into disrepair but Lawren Harris and Dr. MacCallum had it fixed up for Thomson's use. A new floor was put down, the roof made watertight, a studio window put in the east wall, a stove and electric light added. Thomson made himself a bunk, shelves, a table, an easel, and moved in; the rent was a dollar a month. For a time Arthur Lismer also worked in the shack during the daytime. At night, Harris relates, Thomson would put on snowshoes and tramp the length of the Rosedale ravine and out into the country.[43]

Visitors often dropped in at the shack. One of them was the young Thoreau MacDonald:

I often went to Tom's shack behind the Studio Building on Severn Street. This had been a little woodworking shop and it was repaired and lined with beaver-board, that forerunner of all the modern wallboards. Tom lived and worked there winters until his death in 1917. Some unfinished picture usually stood on the easel, and against the wall leaned at various times The West Wind, The Jack Pine, The Pointers, and other less famous paintings.

I was more interested in the canoe paddles and axe in the corner, also a few unfinished axe handles that Tom worked on in intervals of painting, and some handmade trolling spoons and lures hanging

47

on the wall. He made and carved his frames too. Seeing my interest in the axe handles he very characteristically gave me a couple. . . . If you admired his work at all, he was likely to give it to you.

He had a bunk and a little cast iron range for heat and cooking; the shack was clean and tidy. Sometimes he invited me to stay for meals and I remember well the woodsman's flourish with which he threw a handful of tea into the pot and mashed the potatoes with an empty bottle, adding what looked like half a pound of butter. While we ate he drummed his fingers on the table with great speed and vigor. I suppose he was anxious for me to go so that he could get to his work again.[44]

Late in November, 1915, Thomson returned briefly to his home in Owen Sound to see his sister Minnie and her family. In a letter to Blodwen Davies, written in 1930, Minnie described the visit:

In 1915 after 8 years absence in the west the Sask. members of the family paid our first visit home. Tom knew we were coming, and as soon as he could he came up to Owen Sound, landing after midnight. We were all in bed, but my aunt who lived with us, and

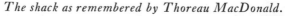

The shack as remembered by Thoreau MacDonald.

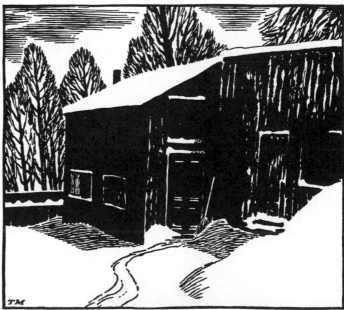

who was very fond of Tom, heard his step and reached the door first. We all dressed and came down and talked till after three. He insisted on sleeping on the couch, and in the morning when we came down he had his blankets all neatly folded, and a plate of buttered toast, and porridge ready for breakfast. We had all overslept, and he thought it a good joke. He had only one day to stay, and that was the last we saw of him.

I noticed a great change in Tom. He seemed engrossed with his work and much quieter. He told us then that he was going to try again to enlist, and if they turned him down he might come west and paint the Rocky Mountains. He was worried too that no one was buying pictures.

In Toronto during the winter of 1915-16, a set of panels was painted as murals for Dr. MacCallum's cottage by Thomson, J. E. H. MacDonald and Arthur Lismer. Included is the figure of a Canadian woodsman, axe in hand, in characteristic garb of Mackinaw jacket, bush pants and heavy boots. Thomson posed for the painting which was done by

Thomson's shack as it is today.

McMichael Conservation Collection, Kleinburg, Ontario

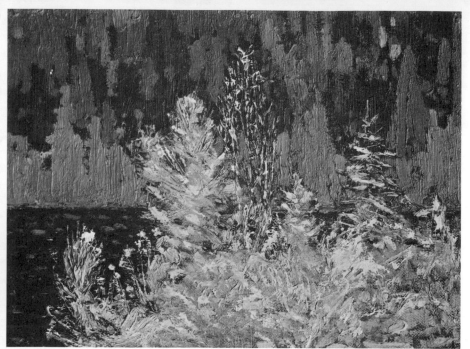

Frost-Laden Cedars, Big Cauchon Lake.
Oil, 12″ x 15″. 1914-15.

J. E. H. MacDonald. He wore his own bush clothes and the easy stance is typically his. Thomson contributed three decorative panels, painted on beaverboard and titled "Forest Undergrowth." Four other panels which he painted for the cottage proved to be too large for the space allotted to them; they are in the collection of the National Gallery.

In 1916, "Spring Ice" was exhibited by the O.S.A., together with three other canvases by Thomson, and purchased by the National Gallery.

Early in the year Thomson and MacCallum made a trip to the north end of the Park. (Thomson refers to this trip in a letter written April 21, 1917.) It is possible (but not confirmed) that Lawren Harris accompanied them and that the following account by him relates to events in the year 1916:

I remember one afternoon in early spring on the shore of one of the Cauchon lakes in Algonquin Park when a dramatic thunderstorm came up. There was a wild rush of wind across the lake and all nature was tossed into a turmoil. Tom and I were in an abandoned lumber shack. When the storm broke, Tom looked out, grabbed his sketch box, ran out into the gale, squatted behind a big stump and commenced to paint in a fury. He was one with the storm's fury, save that his activity, while keyed to a high pitch, was nonetheless controlled. In twenty minutes, Tom had caught in living paint the power and drama of storm in the north.[45]

Recalling the trip years later, Harris commented that Thomson had been "a fine companion—he was so direct and straightforward—and so naturally at home in the woods and lake country."[46]

In 1916 Thomson took a full season's job as fire ranger in the Park. In May he reported at Achray, a station at Grand Lake on the south branch of the Petawawa River.

Firefighting in those days was a primitive affair. With only hand tools—axes, shovels and pails—the fire ranger fought a losing battle. Threatened areas were patrolled constantly and since there were no fire towers, the tallest white pine on a hill would be set up with ladder-steps to serve as "lookout." (Wooden towers were first built in 1917.) In readiness for emergencies, portages had to be kept cleared to facilitate quick travelling. The rangers' most effective work was in educating the timber workers and the railroaders whose locomotives started many of the fires.

Fire rangers were assigned to specific areas of the Park and they worked in pairs. Thomson and Edward Godin followed one of the Booth Company's timber drives down the Petawawa below

51

Grand Lake. It was part of their duty to be near any major work area to watch for carelessness with fire.

Thomson was fascinated by tumbling logs as they came through a dam and from this experience came a vigorous composition, "The Drive," considered one of his most original canvases.

As the summer progressed, the fire situation worsened. In meteorological records, 1916 is listed as a very hot year, with precipitation at a low level. Forests were tinder dry, each coniferous tree a potential torch and even the drought-shrivelled leaves of the hardwoods highly inflammable.

While the situation necessitated constant vigilance, records show no major fires in the areas around Achray. Thomson and Godin found time in quiet periods to fish for speckled trout.

The topography of the north-eastern section of the Park is different from that of the southern parts. The hills are steeper, the rapids become cataracts and the small waterways turn into fast-moving rivers; everything is more majestic.

Thomson wrote MacDonald in July or August:

". . . We have had no fires so far. This is a great place for sketching, one branch of the river (South Branch Petawawa) runs between walls of rock 300 feet straight up. Will camp here when this fire job is finished."[47]

On October 4th he wrote MacCallum from Basin Depot:

I received both your letters at the same time and was glad to hear about things in Toronto. The country up here is just taking the fall colour and by the end of the week will be at its best. Could you arrange to come up this week. You could get a train to Achray at Pembroke Sat. night at 7.30 or more likely 10 o'clock and be here somewhere around 12.

that train leaves from Brent Sunday morning then the next one down is Wednesday morning but I could paddle you down to Peta[wa]wa from here any day you should want to go out.

Have done very little sketching this summer as I find that the two jobs don't fit in. It would be great for two artists or whatever you call us but the natives can't see what we paint for. A photo would be great but the painted things are awful. When we are travelling two go together one for the canoe and the other the pack and there's no place for a sketch outfit when your fireranging.[48]

As Thomson points out, the need for landscape painters had not yet been felt in northern Ontario. The camera, on the other hand, was enjoying great popularity. A brochure advertising Mowat Lodge ("in the heart of nature's paradise") contains the statement: "Photographing live game is one of the greatest sports of the Northland today, and nowhere can it better obtain results. The charming scenery of this territory is in itself sufficient to warrant a long trip with a camera. . . . Splendid photographic opportunities, therefore, exist, and one does well to bring the kodak." On their Mississagi trip in 1912, Thomson and Broadhead did some photographing. Thomson mentions this in his letter to Dr. McRuer: "We got a great many good snapshots of game. Mostly moose . . . but had a dump in the 40 mile rapids which is near the end of our trip and lost most of our stuff. We only saved 2 rolls of film out of about 14." Thomson himself carried a camera during his early days at the Park but by 1916 he appears to have lost interest in film.

Thomson's letter to MacCallum ends: "We are not fired yet but I am hoping to get put off right away. I will expect you Sat. night or any time you can get away." Whether MacCallum was able to make the trip is not known.

53

Many paintings are associated with the northeast areas of Algonquin Park. "Petawawa Gorges" and "The Jack Pine" were painted there. Godin believed that "West Wind" was painted in this area. He stated that Thomson made the sketch during the summer of 1916 at a place near Pembroke, being deeply impressed by the high winds and the scenery along the Ottawa River. This account, however, is contradicted by others claiming different dates and locations for the painting. The Watties believed that the sketch for "West Wind" was done at Round Lake.

In a letter written in 1937, Dr. MacCallum gave the following dramatic account: "It may interest you to know or to add that the 'West Wind' was done at Lake Cauchon. Thomson, myself, Lorne Harris and his cousin Chester were up there. It was blowing very hard and Lorne Harris was painting farther up the shore. The wind blew down the tree of the picture and Harris at first thought that Thomson was killed but he soon sprang up, waved his hand to him and went on painting."[49] Dr. MacCallum gave no date for this incident and Lawren Harris was unable later to supply one.

The Jack Pine. 50¼" x 55". 1916-17.

The National Gallery of Canada

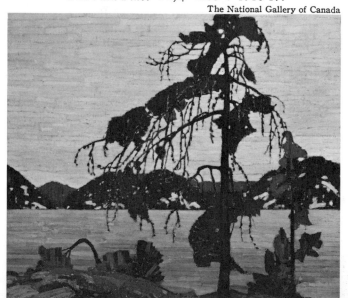

Mark Robinson was certain that he saw the sketch for "West Wind" before he left for overseas in October, 1915. He admired it and Thomson offered it to him. He had refused to accept Thomson's sketches on many other occasions. Again he was reluctant to impose on the artist's generosity; he felt, also, that the sketch had unusual qualities. Thomson agreed, saying that he would prepare a canvas from it and give the sketch to Robinson later. Robinson left on army service shortly afterwards. Thoreau MacDonald has a dim memory of seeing Thomson working on the canvas for "West Wind" in his shack during the winter of 1915-16.

The problem of finding specific locations for Thomson's paintings is aggravated by the fact that the country has changed greatly since he painted there. Water levels at Canoe Lake are substantially higher than in his time. In other areas rivers have shrunk to creeks. Trees have been destroyed by fire, lightning, old age and disease. Only the shapes of the rocks and hills in the backgrounds remain as they were and these are rarely sufficient to pinpoint a location.

Some of Thomson's sketches depicted well known spots near Mowat Lodge, in the Canoe and Smoke Lake areas. Those who knew the Park had little trouble in identifying these in later years. In other cases, there were no real landmarks by which to place the paintings. Today the original Mowat Lodge is gone as well as the building which replaced it. Part of the foundation of Gilmour's mill may still be seen and the shallow waters nearby are filled with sawn lumber and debris from earlier days.

Records for Thomson's life during 1916 are sparse. In 1931, when she was preparing her biography of Thomson, Blodwen Davies wrote to Godin in an effort to obtain more information. In his reply, Godin described how "West Wind" had been painted, then continued:

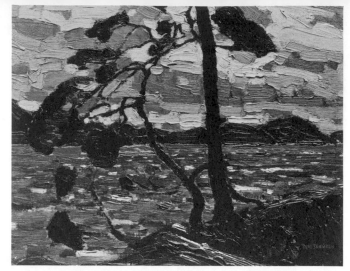

The West Wind. Panel, 8½″ x 10½″.
The West Wind. 1917. Oil, 47½″ x 54″.

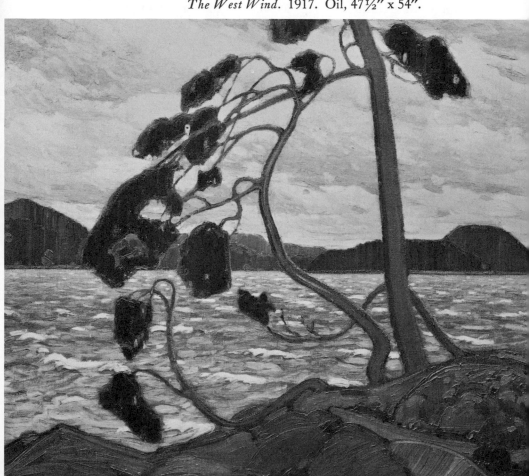

As to his point of view in painting I am unable to enlighten you. At times he would not sketch at all being quiet and moody for days. He used to mention a man named Hemming, in Toronto a lot also a Dr. McCallum. Hemming I think was an artist or an Author.[50]

We had many discussions on the war. As I remember it he did not think that Canada should be involved.

He was very outspoken in his opposition to Government patronage. Especially in the appointment of Commissions in the Militia. . . .

I am sorry that I am unable to give you more information but I have forgotten a lot of our conversations of that summer.

Most of the men with whom Thomson spent time fishing, guiding, and camping in Algonquin Park, left no written records. Thomson himself wrote few letters and those he did write are short and unrevealing. Unless information is provided through other sources in future, we can have little idea of the artist's inner life, his thoughts, opinions, anxieties or hopes, during his years in Algonquin Park.

On his return to Canoe Lake, Thomson interrupted his work briefly at the request of Taylor Statten who was building a cottage on Little Wapomeo Island. A supply of sand was required for the construction of a fireplace chimney. Thomson hauled it from Sim's Pit across Canoe Lake to the island with team and scow. Although inconvenienced, he felt it an obligation to do so, as he had occasionally earned money when he needed it by clearing underbrush on Little Wap; it was a point of honour always to return small favours.

Late in the year Thomson returned to Toronto. In his absence a storm of criticism had been directed at his fellow painters mainly as a result of MacDonald's "Tangled Garden," exhibited early in 1916.

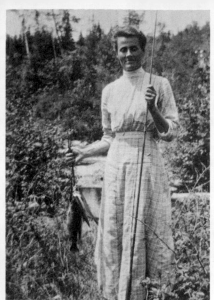

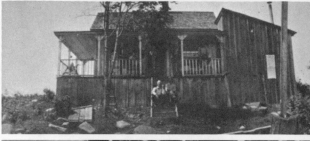

Winifred Trainor
(1884-1962).

LOWER: *Dr. R. P. Little in 1916; background, Taylor Statten's cabin on Little Wapomeo Island.*

UPPER: *In Gilmour Lumber days, this building was referred to as "the manse." From 1908 to 1912 it was used as a shelter hut by rangers who called it "the Canoe Lake berth." After 1912 it became a summer dwelling for the Trainor family.* (Photographed about 1908).

While he shared in the abuse, Thomson did not involve himself in theories of painting or in answering critics' comments. With his own wry humour, he told of leaving sketches on the trail to dry while he travelled further on. When he returned, he found the paintings scratched and chewed by animals who, he thought, made excellent critics.[51]

The problem of drying sketches was a recurring one. The tent was not a suitable place in which to keep them. He once packed some sketches in a suitcase and sent them from South River to MacDonald in Toronto, with a covering letter: "Will send some sketches down in a day or so, and would ask if you would unpack them and spread them around in the

shack, as I am afraid they will stick together a great deal."[52] Sometimes at the Park he would store sketches in a ranger's cabin, or set them up in the old hospital building, or at Mowat Lodge. Occasionally, he made use of the cottage of Hugh Trainor, a foreman for the Huntsville Lumber Company. The cottage had been at one time a shelter hut and was used by rangers before the Joe Lake and Smoke Lake shelter houses were built. Winifred, comely elder daughter of Hugh Trainor, took a great interest in Thomson and his work. Tom visited her at Huntsville and gave her some of his sketches. One or more of these are reportedly of houses on the street in Huntsville where the Trainors lived.[53]

The winter of 1916-17 was spent in the shack where Thomson completed "The Jack Pine," one of his most important canvases. The brushwork of this painting makes it very difficult to photograph; to be properly evaluated, the original canvas must be seen.

He worked on "West Wind" also but was dissatisfied with it. He discussed this canvas on several occasions with J. E. H. MacDonald. Problems seemed to arise from the combination of two styles (formalized tree against a natural background). In spite of Thomson's misgivings, the painting was widely accepted by the public in later years and became eventually one of his best known works.

Early in April, 1917, Thomson was at the Park again. On April 16th he wrote to his family: "I did not send any paintings to the O.S.A. Exhibition this year and have not sold very many sketches but think I can manage to get along for another year at least. I will stick to painting as long as I can."[54]

About the same time he wrote to his brother-in-law, T. J. Harkness:

Dear Tom:

I have been here over three weeks and have done considerable work for that length of time.

I got a copy of the O.S. *Sun* and it seemed to be filled with bunk. However the foolishness of newspaper matter is well known and I knew nothing about it in time to have it stopped.

I have been talking to the people here at the Post Office [Mowat Lodge] about pigs. Have been advising them to get about 6 or 8 small ones and keep them till fall which they could do without much expense and hang them up for the winter. Supposing they deside to try it out what would they have to pay for the pigs and where would be the place to send for them—and could they be shipped by express or freight any distance.

Am staying at the P.O. until the ice goes out of the lakes which I expect it to do sometime this week then I will be camping again for the rest of the summer. I have not applied for the fire-rangers job this year as it interferes with sketching to the point of stopping it altogether so in my case it does not pay. In other words I can have a much better time sketching and fishing and be farther ahead in the end.

I may possibly go out on the Canadian Northern this summer to paint the Rocky's but have not made all the arrangements yet. If I go it will be in July & August.

We still have a foot or two of snow on the north side of the hills yet but another week will see the end of it, and we have nearly another month before my friends the black flies are here. The leaves do not come here before May 24th and often not until on in June.

Well I will get this started towards Annan hoping you are all well there."[55]

The article in the Owen Sound *Sun* to which Thomson refers appeared in the issue of April 10, 1917.

The reporter had visited Thomson's shack in his absence and wrote an enthusiastic account of the paintings he saw. He commented on Thomson's use of colour, adding: "Though at first the brilliancy rather daunts one, before the end is reached the real art in the canvases becomes apparent and the duller canvases are tame." The caption above the article reads: "Pictures by Sydenham boy worth seeing."

A supply of fresh meat and vegetables was always a problem in the north, owing to the lack of refrigeration and the long railroad haul from the major sources of supply. It was not uncommon for Park residents to import small pigs and fatten them.

Thomson was working at this time on a series of sketches to reflect the changing scene from day to day as the year progressed. Mark Robinson recalled a chilly night when he painted the Northern Lights. The temperature had dropped sharply and the sky was brilliant with colour. Thomson spent the early part of the evening at Robinson's shelter house, watching the sky and coming in at intervals to warm himself by the fire. About midnight he got his paints from Mowat Lodge and went down to Lowrie Dickson's cabin where he would have a better foreground

Setting off for Canoe Lake Station, winter, 1917. L. TO R.: *R. P. Little, Lowrie Dickson, Lieut. R. Crombie, Mrs. Crombie, Charlie Scrim, Shannon Fraser. Thomson's room was the second window from the right upstairs.*

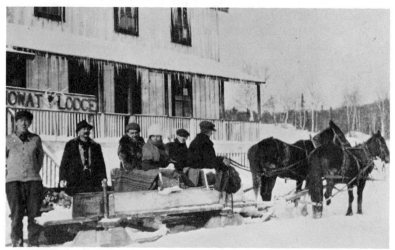

for his sketch. He lit a fire in the stove and set to work. The painting was done by lamplight, between midnight and eight in the morning.

Thomson was never satisfied, says Robinson, unless he got the "feel" as well as the look of the country. Shortly after painting the Northern Lights, Thomson sketched three ragged black spruce against a cold, green-coloured sky. He showed the sketch to Robinson and an old ranger who was visiting him. The latter remarked: "Oh it would make you freeze to look at it." Thomson, it appears, liked that kind of compliment.

In a letter written on April 21st he invited **Dr.** MacCallum to visit the Park that spring:

I have been here for over three weeks and they have gone very quickly. For the last two or three days the weather has been fairly warm and last night we had quite a heavy thunder storm and the snow is pretty well cleared off. Just patches in the bush on the north side of the hills and in the swamps so now I will have to hunt for places to sketch when I want snow. However the ice is still on the lakes but it is very thin this year on account of deep snow over it through the winter so it will not last very long.

If you can come up here this spring I think we could have some good fishing and the animals are more plentiful on this side of the park than where we were last spring. I would suggest that you come some time around the tenth 10th of May as the flies are not going properly until about the 24th It is likely that the ice will be out sometime this month

Have made quite a few sketches this spring. have scraped [scrapped] quite a few and think that some that I have kept should go the same way. However I keep on making them.[56]

In a further letter to MacCallum, dated May 8,[57] he made the following suggestion which illustrates the kind of planning he was accustomed to do:

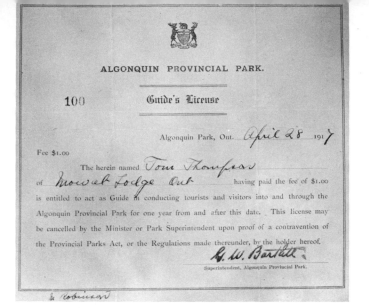

ALGONQUIN PROVINCIAL PARK.

100 Guide's License

Algonquin Park, Ont. *April 28* 191*7*

Fee $1.00

The herein named *Tom Thomson*

of *Mowat Lodge Ont* having paid the fee of $1.00

is entitled to act as Guide in conducting tourists and visitors into and through the Algonquin Provincial Park for one year from and after this date. This license may be cancelled by the Minister or Park Superintendent upon proof of a contravention of the Provincial Parks Act, or the Regulations made thereunder, by the holder hereof.

G. W. Bartlett

Superintendent, Algonquin Provincial Park.

Thomson's guide license.

Could you not stop off at Canoe Lake on your way up. It is eight miles this side of the Highland Inn and is the best starting point going either north or south. If you wanted to see the outfit at Cache Lake would you come back to Canoe Lake on the afternoon train which leaves there at about 2:30 p.m. and you would be back here in about 20 minutes, otherwise I would have to pack the outfit over 2 or 3 portages and we would have it back again where we could see the same places from Smoke Lake going light. You can get extra blankets or stuff from Fraser, and I have all the supplies including 1 gallon maple syrup pail of jam plenty bacon, potatoes, Bread, tea, sugar, all kinds canned stuff, tents canoes cooking outfit plates etc. I tried to get some chocolate and failed have no "Klim" & no Coffee. That I think is everything we need for two or three weeks including Williamson.[58] The weather for the last two days has been fine and warm. Will expect you either Friday or Saturday and will not go over to Highland Inn unless you want specially to start out from there. If the weather is bad we may arrange to get in one of the Rangers shelter huts.

During the early months of 1917, Lieutenant Robert Crombie was making an extended visit to Mowat Lodge while recuperating from an illness. Mrs. Crombie, young and newly married, came in one day with some wildflowers she had picked. She wandered through the Lodge looking for something to put them in. Thomson noticed that she looked disappointed at having to use an ordinary glass jar as a vase and offered to decorate it with any flowers she chose. She chose pussy-willows and Thomson arranged them in a diagonally-shaped pattern over a solid blue background. Mrs. Fraser later broke the vase while dusting.

A pencilled caricature of Lieutenant Crombie drawn by Thomson is in the collection of the National Gallery. In his youthful days, Thomson had delighted in drawing caricatures. Legend says that he left sketches of the minister in many of the Leith Presbyterian church hymn books. Young people often put on minstrel shows in the communities near the

Pencilled caricature of Lieutenant Robert Crombie by Tom Thomson, April 1917. Inscribed by James MacCallum. 10½" x 8⅜".

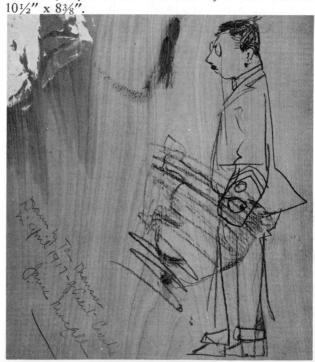

Thomson home and Tom supplied advertising placards for them. Once he sketched the local miller and below it printed "Young People Must Be Amused," the miller's favourite saying.

Mrs. Crombie recalled that in those days at Mowat Lodge Thomson was not talkative but appeared confident in his work and not unhappy. Ordinarily he would be out-of-doors every day, sketching or fishing. In the evening he sat reading quietly in a corner of the "lobby." The Lodge had been enlarged by the addition of the old mill storehouse. However, it was still poorly heated and the furnishings makeshift. Mrs. Fraser appeared to do most of the work while her husband looked after the horses which he kept in the barn nearby.

Occasionally Thomson worked on a sketch indoors, sitting by a window of the storehouse addition which was then empty and unheated. From this window he had a view down Canoe Lake. Mrs. Crombie would ask questions about what he was doing and he would answer patiently, in the manner of a man who was used to sisters. During the spring of 1917 Thomson held an "art show" and invited each guest at the Lodge to choose a sketch for himself. Mrs. Crombie's choice was a winter scene which showed prominent deep blue shadows on snow. She questioned the colour of the shadows and Thomson suggested that she watch them as they changed colour throughout the day. By four o'clock or so, he said, the bluish colour would have deepened. The cold, clear air of Algonquin gave a diamond-like brilliance to most of Thomson's colours, and in this sketch sunshine and shadow come into sharp relief.

It was during this spring that Thomson painted the picture known as "The Artist's Hut." (This was Larry Dickson's new cabin—Thomson never lived there.) Mrs. Crombie and Mrs. Fraser happened to walk by and he painted them in.

In response to Thomson's letter, Dr. MacCallum arrived at the Lodge with his young son, Arthur, and stayed overnight. Thomson showed him the sketch of an unusual sunset. MacCallum pretended to consider it much exaggerated and Mrs. Crombie, who had observed the sunset with Thomson, vigorously defended the artist's accuracy.

MacCallum's visit is evidence of his continuing interest in Thomson, the artist whom he had helped to start on a career of full-time painting. His concern for Thomson's welfare and his unwavering faith in his work must have earned the artist's deepest gratitude. It is said that in MacCallum's opinion Thomson was the greatest of the artists in the movement he helped to foster. In later years the walls of MacCallum's house and office were covered with Thomson's sketches and he loved to show them to visitors.

The Crombies left Mowat Lodge late in May. Earlier in the year a friend from Ottawa, Charlie Scrim, had arrived in the Park. He also was recuperating from an illness. He and Thomson spent some time fishing together. Thomson put in gardens for Frasers and the Trainors. Tom Wattie looked forward to seeing him again at the north end of the Park.

Mark Robinson recalled a conversation which he had with Tom Thomson about July 4th, 1917. Thomson asked if he could hang his series of sketches (he usually referred to them as his "boards") recording the unfolding year around the walls of Robinson's cabin. Robinson was reluctant to take responsibility for the sketches as he was often called away but agreed to look after them at a later date. There was some talk that day about a big trout below Joe Lake Dam that both had been trying to catch for some time. It was their last conversation. On July 7th Thomson wrote a letter to Dr. MacCallum:

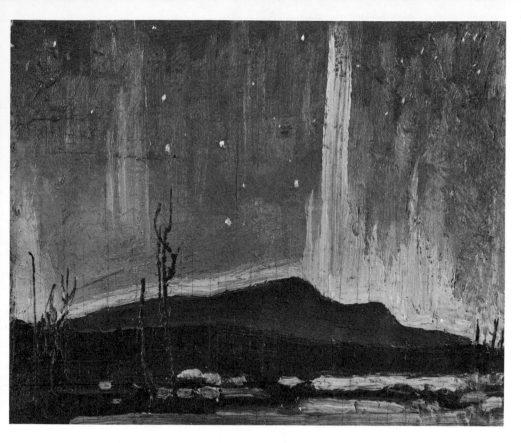

Northern Lights. 1916-17. Oil, 8¼" x 10¼".

I am still around Frasers and have not done any sketching since the flies started. The weather has been wet and cold all spring and the flies and mosquitos much worse than I have seen them any year and fly dope doesn't have any effect on them. This however is the second warm day we have had this year and another day or so like this will finish them. Will send my winter sketches down in a day or two and have every intention of making some more but it has been almost impossible lately. Have done a great deal of paddling this spring and the fishing has been fine. Have done some guiding for fishing parties and will have some other trips this month and next with probably sketching in between . . ."[59]

On Sunday July 8 Thomson was seen starting off about noon in his canoe with his usual fishing equipment and supplies. The events of the following week are recorded as follows in Mark Robinson's Journal:

Tuesday, 10: Morning wet and cool. Mr. Shannon Fraser came to house about 9:15 A.M. and reported that Martin Bleacher (*sic*) had found Tom Thompson's canoe floating upside down in Canoe Lake and wanted us to drag for Mr. Thompson's body.[60] We went to Canoe Lake and interviewed Miss Bleacher who was with her brother on Sunday in his little motor boat. Going to Tea Lake dam they passed a canoe floating upside down between Stattons Point and the Bertram Island. They didn't stop to examine the canoe as they had heard there was a canoe that had drifted away from its moorings and had not been found but they intended to pick up the same as they returned. They passed canoe at 3:05 P.M. on Sunday the 8th. After hearing different evidence we returned expecting to hear of Mr. Thompson returning soon.

Mark Robinson and son Jack at Joe Lake Station about 1915.

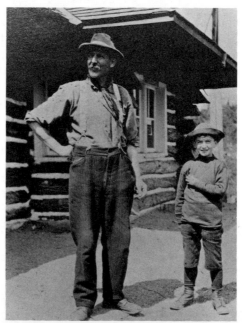

Wednesday, 11: We three Rangers along with Martin Bleache[r] searched the shore of lake and various portages without result.

Thursday, 12: Morning wet. Mr. Thompson, a brother of Tom Thompson, arrived here today. I took him around the lake and we met several people and interviewed them. Albert Patterson went to Huntsvill[e] to search into matters there. . . . Rain fell most of afternoon.

Friday, 13: Morning wet. We returned to Canoe. Myself and son Jack Robinson searched Bertrams Island and the western shore of Canoe Lake also the portage to Gaunther Lakes to which we carried our canoe. After searching the Gaunther Lakes we went north up the Gilmore road for about half a mile when we turned west for about a mile then north to a large beaver pond which we went around and travelled south to Gills Creek where we turned west to Gills Lake. At Gill's Lake we found Mr. Colsons canoe or canvas boat. Found no traces of any person having been there for some time. We returned to Canoe Lake having called on Mr. Fraser and Mr. Thompson. We also called on Mr. Lowrie Dixon and fire Ranger MacDonald then returned home and met evening train.

Saturday, 14: Morning fine. Ranger Patterson returned this morning having visited Huntsvil[l]e getting no information of importance regarding Tom Thompson. I was feeling very tired and remained at home all day meeting trains etc. Ranger Patterson returned to Moose Lake. Mr. Thompson left for his home this morning.[61]

Sunday, 15: Morning wet. I went and patrolled east and north shore of Canoe Lake in search for Tom Thompson. Found no trace of him and I returned home.

Monday, 16: Charles Scrim reported that Tom Thompson's body was found in Canoe Lake by Geo Rowe this morning about 9 A.M. I reported to Mr. Bartlett over the phone and he wired for the coroner and County Crown Attorney. Body found by Dr. G. W. Howland,[62] M.B., M.R.C.P. of 538 Spadina Ave., Toronto, who directed Guides Geo Rowe and Lowrie Dixon to body. They took same and put it near shore. Later Martin Blecher Jr. and Mr. Hugh Trainor put blanket over body and it remained there all day.

Tuesday, 17: Morning fine. Undertakers Dixon and Flavell came in last night, Roy Dixon staying with me. This morn Supt Bartlett ordered me to await arrival of Dr. Ranney cor. from North Bay, should he not arrive to have body taken out of water and put in casket. This we did. Dr. Howland examined body at my request. We found a bruise on left temple about four inches long. Evidently caused by falling on a rock. Otherwise no marks of violence on body. Dr. Howland and undertakers advised having body buried. I reported to Supt. Bartlett by phone and he ordered him buried which we carried out at little cemetery at Canoe Lake, Mr. Martin Blecher Sr reading the funeral service. Miss Winifred Trainor and Miss Terry went out on the evening train. About 8 P.M. Dr. Ranney arrived and took the evidence of Mr. Edwin Colson at Joe Lake. We then went to Canoe Lake and met at Martin Blechers home where I had assembled Dr. Howland, Mr. and Miss Blecher, Hugh Trainor, Geo Rowe and self. Evidence was taken etc.[63]

Wednesday, 18: About 1:30 A.M. Martin Blecher Junior brought Dr. Ranney and self up Joe Creek in yacht to portage from where we walked to Joe Lake Shelter House arriving there about 2:30 A.M. Up at 6 A.M. and Dr. Ranney took train to North Bay. I met trains as usual. Later in day . . . S. Fraser rec[e]ived telegram that a steel casket

was being sent in and Thom Thompsons body was to be exhumed and taken out by whose orders I am not at present aware. There is considerable adverse comment regarding the taking of the evidence among the residents.

Thursday, 19: . . . Mr. Churchill undertaker of Huntsville, Ont., arrived last night and took up body of Thomas Thomson artist under direction of Mr. Geo Thompson of Conn. U.S.A. The body went out on evening train to Owen Sound to be buried in the family plot

The Arts Ass[ociation] purpose having a Memorial Exhibit of Mr. Tom Thomson's paintings and to place a memorial in the Park near where he loved to work [and] sketch so well. Thus ends a career of unselfishness of a gentleman, sportsman, artist and friend of all.

Tom Thomson died shortly before his fortieth birthday. His body was taken for burial in the graveyard at Leith.

In September, 1917, a memorial cairn was placed on a hilltop near Hayhurst Point overlooking Canoe Lake. J. W. Beatty was responsible for the stonework and the bronze plate was designed by J. E. H. MacDonald. It was engraved by Alexander and Cable of Toronto and the completed memorial was a tribute from Thomson's friends and fellow artists who knew his true worth.

The verdict given at the inquest was "death by accidental drowning." It was based principally upon the report of Dr. Howland.

The criticism referred to by Mark Robinson arose from the hurried nature of the coroner's investigation. Robinson was an Army officer with the rank of Major who had returned only recently from active duty overseas. His military training and experience made him conscious of the importance of the procedures to be observed in conducting an inquest. In

Death Certificate

Name: Thompson
Ch.: Tom. J.
Age: 42
Sex: male
Date of Death: July 8. 1917
Name of father: John Thompson
mother: Margaret Thomson
Occupation: Artist
Residence: Camp Case - Mowat Lodge & Tomb
Cause of Death - Accidental Drowning.
Physician - Gustav Hara M.D.
538 Spadina Av Tomb

Name: Thompson
Ch.: Tom. J.
Age: 42
Sex: male - Single
Name of father: John Thomson
mother: Margaret Thomson
Occupation - Artist
Residence: Mowat Lodge - Tomb
Cause of Death - Accidental Drowning.
Name of person making return: M Robinson
Relationship to person: None

A. E. RANNEY, M.D., C.M.
NORTH BAY, ONT.

July 19/17

Mark Robinson
Joe Lake. Ont.

Dear Sir. Enclosed please find death certificate for Superintendent also burial certif. for undertaker and warrant to chief constable to take possession of body, although late. These are necessary.

Tell Dr. Howland. to send me his Toronto address, and fee of $5.00 will be sent him by Government.

Thanking you all for your kindness and remember me to the Bleechers Family who were also very kind to me.

Yours Truly
A. E. Ranney

Sold by Joseph Doust, Law Stationer, 58 Adelaide St., E. Toronto

WARRANT TO BURY AFTER A VIEW.

CANADA
Province of Ontario
of
TO WIT:

To the person in charge or control of burying grounds in the *at*
Canoe Lake Algonquin Park. Ont
and to *All Others Whom It may Concern.*

Whereas an Inquisition hath this day been held upon view of the body of *Thomas Thompson*

who now lies dead in your *Township*

These are therefore to Certify that you may lawfully permit the body of the said

Thomas Thompson ———————— ———————— to be buried

AND FOR YOUR SO DOING **THIS IS YOUR WARRANT.**

Given under my hand and seal this *17ᵗʰ* day of *July* 1917

A. E. Ranney, M.D.
Coroner

Temporary death certificate and release of body for burial
pending arrival of coroner.
Certificates issued by coroner, Dr. A. E. Ranney.
Letter of explanation regarding issue of certificates.

Sold by Joseph Doust, Law Stationer, 58 Adelaide St., East, Toronto

CORONER'S WARRANT TO TAKE POSSESSION OF BODY.

CANADA
Province of Ontario
of
TO WIT:

To the Chief Constable of the *Canoe Lake Algonquin Park*
Ont of
in the *District* of *Nipissing*

By virtue of my office these are in HIS MAJESTY'S name to charge and command you that on sight hereof you forthwith take in charge the body of *Thomas Thompson* ——— ——— ——— deceased now lying dead at *Canoe Lake Ont.*

And thereafter do and execute all such things as shall be given you in charge on behalf of our SOVERIGN LORD THE KING touching the death of *Thomas Thompson*

and for your so doing this shall be your sufficient **WARRANT**.

Given under my hand and seal this *17ᵗʰ* day of *July* 1917

A. E. Ranney, M.D.
Coroner

common with many others who were familiar with Thomson's abilities, Robinson found it difficult to accept the simple explanation of "accidental drowning" in the death of so skilled a woodsman.

There were a number of troubling circumstances which might have been explained immediately had sufficient time and care been taken at the inquest. In the absence of factual evidence, a host of rumours sprang up and with them, inevitably, claims of foul play.

Over the years speculation has continued. The life of Thomson early took on a legendary quality and his mysterious death contributed to the legend. It is idle to examine the various theories advanced to explain his death. Many of them are far-fetched and misleading; facts to support any theory are almost impossible to obtain. It appears unlikely now that any completely satisfactory explanation of Thomson's death will be found.

A note about Tom Thomson, artist from Mark Robinson's Daily Journal, July, 1917.

EPILOGUE

Thomson's death was a stunning blow to his family and to the small group of painters who were his devoted friends.

For the Thomsons it was the first break in a large, adult family. The concern they had felt for Tom in the years preceding his death is expressed in a letter from Margaret Thomson (Tweedale) to Dr. Mac-Callum: "He was so much alone that we seemed to think more about him than any of the other members of the family."[64]

On August 4, 1917, A. Y. Jackson wrote from overseas to J. E. H. MacDonald:

Without Tom the north country seems a desolation of bush and rock. he was the guide, the interpreter, and we the guests partaking of his hospitality so generously given. His name is so often coupled with mine in this new movement that it seemed almost like a partnership, and it was, in which I supplied the school learning and practical methods of working and helped Tom to realize the dreams which were stored up in the treasure house while my debt to him is almost that of a new world, the north country, and a truer artist's vision because as an artist he was rarely gifted.

Later the same month he wrote again:

I have heard nothing further about Tom but conclude it is only too true. I know how keenly you will feel his loss. You had very much in common. Tom I know though he was a man of few words often expressed to me his confidence in you and in the future of your work, and without you he never would have associated himself with our little school. Well it is a blessing that the last years of his life were

75

devoted as they were. he has blazed a trail where others may follow and we will never go back to the old days again.[65]

While the general public remained unaware of its loss, one or two discerning writers expressed concern at Thomson's passing. An obituary notice in a Toronto newspaper praised him as "one of the few young men whose work expressed the spirit of the wild and remote places of Canada." *Studio* Magazine (New York) in its issue of September 1919 published a brief but perceptive article by H. Mortimer Lamb in which he spoke of a "latent genius suddenly blazed forth" and noted Thomson's "extraordinary individuality, charm and power" and his "typically Canadian spirit."

At Thomson's death, many of his paintings remained unsold. During his lifetime, three canvases had been acquired by the National Gallery, Ottawa. Dr. James MacCallum had bought a great many sketches and helped to find purchasers for others; the price was usually about $25. In 1918, "The Jack Pine," "Autumn's Garland" and twenty-seven sketches were purchased for the collection of the National Gallery. Eric Brown, the Gallery's first director, had early recognized Thomson's talent; in a letter written in 1922 he referred to the artist's work as "precious" and "unique."

A "Memorial Exhibition of Paintings" was held in February 1920 at the Art Gallery of Toronto. A total of forty-seven paintings was shown, including most of Thomson's finest work. A reviewer for the Toronto *Mail and Empire* found it necessary to begin: "That the majority will be shocked and startled and amazed is to be expected." But he concluded:

In studying his [Thomson's] pictures it is apparent that he possessed an immense appreciation of colour, that he was original and daring in design, that he

76

broke away from the old methods in favour of a more direct handling of his pigments, that he studied broad and comprehensive treatment of his subjects rather than meticulous detail, that he was more concerned with the idea of his composition than the manner of its expression, that he was willing to sacrifice some aerial perspective to secure brilliancy of treatment, and that he was more interested in abstraction than in paltry particulars. Genius, however, in the end escapes analysis, and perhaps all that can really be said is that many of his pictures are colour raptures and that the great, free spirit of the northland blows unrestrained through his glowing and emancipated canvases.[66]

Not all critics were so enlightened. From 1913, when they were dubbed "The Hot Mush School," a stream of abusive comment had been directed against the work of Thomson and his friends. When the Group of Seven was formed in 1920, its members fought back against attackers who called their work "freakish," "garish," "meaningless," "products of a deranged mind."

The tide of disapproval was stemmed to some extent by the reception given the artists' work in England at the important British Empire Exhibition held at Wembley in 1924 and again in 1925. Eric Brown described the opening as follows:

Our pictures were hung and looked well. They had colour, force, individual attack, and deep sincerity. The art critics . . . came drifting into the galleries . . . Gasps of surprise Here was something new! They talked to each other, they talked to us. They wanted to know if Canada really looked like this. Were the shadows on the snow really as blue as Albert Robinson had painted them? Surely MacDonald had exaggerated the brilliance of the autumn colours. Who were all these painters, and why had their work never been seen before?[67]

77

The *Times* of May 6, 1924, referred to Thomson's "Jack Pine" as the most striking work at Wembley.

As a result of this success, the Ministry of Fine Arts of France extended an invitation to the National Gallery of Canada to form an exhibition of contemporary Canadian Art in Paris during the spring of 1927. Pictures were selected from those shown at Wembley with the addition of separate retrospective showings of the work of Tom Thomson and James Wilson Morrice. To this was added a collection of West Coast Indian art.

In Paris Tom Thomson received unqualified praise. The art critic for *Le Figaro* wrote: "Thomson never fumbles. . . . His painting is strong, and without subterfuge, the painting of a man immensely concerned with the nature he depicts."[68]

At an exhibition in Ottawa, later the same year, the Canadian public was still unconvinced and reception was unenthusiastic.

In Toronto, also, recognition lagged. At the end of 1925 Thomson's canvas "West Wind" had not yet been sold. In March, 1926, it was finally purchased by the Canadian Club of Toronto and presented to the Art Gallery there.

In 1932 Thomson's work was chosen for exhibition at an Imperial Conference in England. Subsequent exhibitions at Buenos Aires and Johannesburg, London, and New York made the work of Thomson and others known abroad. In Canada travelling exhibitions of Canadian art were held.

The work of Thomson was shown with that of Morrice at an Imperial Conference in 1937. In the same year an exhibition of Thomson's works was held at Mellors Galleries in Toronto. A review by art critic Graham McInnes contained the statement: "This exhibition is a revelation to those, like myself, who heretofore have been unable to view at one time a large collection of Tom Thomson's work."

In an article prepared for the catalogue, Dr. James MacCallum stated that aside from the artistic merits of Thomson's sketches, they had a "historical value entitling them to preservation in the National Gallery."

Many Canadians were first introduced to the work of their country's artists through the appearance and distribution of silk screen reproductions. A number of these were prepared soon after the outbreak of war in 1939 and under the sponsorship of the National Gallery, the armed forces and the Canadian Legion Educational Services, were circulated widely. They were hung on the walls of many training camps, barracks, and factories both at home and abroad. Copies were purchased for schools, hospitals and business offices as well as for private homes. Thomson's "Spring Ice," like Jackson's "Red Maple" and other Canadian paintings, became known from coast to coast.

Interest in Thomson, his lonely life and mysterious death, was always keen among young campers and visitors to the Canoe Lake area. Over many years, Taylor Statten Camps sponsored art shows and employed professional artists who nurtured this interest. The totem pole near the cairn and the legend of the ghostly grey figure who haunts Canoe Lake are the creations of young people whose imagination had been caught by the vision of Tom Thomson and what he tried to do.

In 1943 a two-reel colour film entitled "West Wind" was released by the National Film Board, its subject the work of Tom Thomson. At its opening, A. Y. Jackson paid tribute to his old friend and mentioned that sketches by Thomson which had once sold for $25 were now valued at ten times that amount and hard to come by. In May 1967, a sketch 8½ x 10½ triple-authenticated sold at public auction in Toronto for $15,250.

In August, 1961, a plaque honouring Thomson's memory was unveiled at Leith, where he grew up. In 1963 his name was in the news when forgeries of his paintings were discovered to be circulating. Thomson in his later days did not sign all his paintings. After his death, J. E. H. MacDonald designed an identifying stamp which was placed on the works remaining to be sold. The forgeries, endorsed with a replica of this stamp, were not copies of Thomson's paintings but works in his style. Collectors sent their supposed Thomsons to the National Gallery to be verified and investigation followed. Two of the unscrupulous dealers who sold them were later imprisoned.

By 1967 the name of Tom Thomson had become a household word, and appreciation of his work was general. A ten-cent postage stamp with "The Jack Pine" as its subject was issued for Centennial Year and Thomson's work formed part of a major touring exhibition entitled "Three Hundred Years of Canadian Art." At Owen Sound the building of a Memorial Gallery named for him was completed. Examples of his work provided the major stimulus for the creation of the McMichael Conservation Collection at Kleinburg, Ontario, a public institution since 1965, where paintings by Thomson are on permanent exhibition.

Paintings by Tom Thomson

During his brief career as a full-time painter, Tom Thomson completed about twenty canvases and over four hundred sketches. Many prefer the sketches to the larger works.

His subjects range from distant skies and hills to small groups of wildflowers, from drowned land and burnt country to the lush growth of interior marshes,

from icy streams and tree buds in spring to the richest autumn colours, from a casual campsite to the studied magnificence of "The Jack Pine." In the words of Dr. James MacCallum, his works constitute "a complete encyclopaedia of all the glories of Algonquin Park."[69]

The swift change in Thomson's work from his small and dark early pictures to brilliant colour and confident brush work is very striking. It was brought about probably by the country itself, a kind of adaptation to environment, and by the influence and encouragement of his associates, notably J. W. Beatty, A. Y. Jackson, Arthur Lismer, J. E. H. MacDonald and A. H. Robson.

Some critics have commented on various influences which they find in Thomson's work. They note the reflection of Scandinavian style in "Northern River," the use of pointilliste technique in "The Pointers," traces of Art Nouveau in "Autumn's Garland" and other paintings.

The Canadian painters who worked with Thomson were acquainted with contemporary European styles. It would be, however, a gross error to suppose that they consciously imitated or approved the use of foreign techniques to depict the Canadian landscape. Thomson himself was never interested in theories of art; when conversation turned to such matters, says Thoreau MacDonald, "Thomson walked out." He adds: "In a lifetime of association with the Group members I never once heard 'Art Nouveau' mentioned and Scandinavian painting merely made them feel they were on the right track. The great final influence was country and climate. Thomson, Jackson, MacDonald, these three especially, tried to express and record their country as best they could and from this effort their style evolved."

The technical side of painting interested Thomson greatly and he experimented constantly. He chose,

almost at random, subjects which the insensitive would pass by, and never became static in his outlook. He guarded his independence and even in 1914, when he was receiving much help from his associates, judged unnecessary MacCallum's warning not to let "that fellow Jackson" influence him too much. From 1915 on, he worked alone in the Algonquin woods. Confronted by an ever-changing landscape, absorbed in problems of light and colour, he gradually became a master of his craft, acquiring over the years a remarkable speed and facility.

The qualities of directness and sincerity often commented upon in Thomson's work are consistent with his own character. He was a man who detested affectation or pretentiousness of any kind. Sketching in wild country was for years his way of life. At times he seems to have become completely assimilated into his environment and to have painted almost by instinct. Lismer recalled: "When the rest of us were slaving to harmonize the contrast of some autumn colour-composition I have seen Tom leisurely open his sketch box and allowing himself to go with the stream catch in a few moments the spirit of the scene without being at any time conscious of our problems."[70] J. E. H. MacDonald confirms this: "as for Tom," he wrote, "he didn't consciously analyze. He worked from the inside *feeling* and he let that govern him."[71]

The decorative effects of Thomson's larger canvases underline his skills as a designer. Yet even in these less intimate studies, where a degree of abstraction may be found, nature remains predominant.

Members of the Group of Seven acknowledged their debt to Thomson. Together these painters opened their countrymen's eyes to the beauty of the northland and Thomson's work became the chief inspiration for Canada's first genuine national movement in art.

During Thomson's lifetime, three canvases were acquired for the National Gallery: "Moonlight, Early Evening," "Northern River" and "Spring Ice." The present collection includes in addition "The Jack Pine" and "Petawawa Gorges" as well as other canvases and over one hundred sketches. Dr. James MacCallum bequeathed his Thomson collection to the Gallery at his death; panels from his cottage on Georgian Bay presented to the National Gallery in 1968 by the present owners, Mr. and Mrs. H. R. Jackman, include his own work and a portrait of him by J. E. H. MacDonald. The Vincent Massey bequest of 1968 includes several fine sketches.

"West Wind," "Drowned Land," "Bateaux" and other paintings are in the collection of the Art Gallery of Ontario, Toronto.

"In the Northland" may be seen at the Montreal Museum of Fine Art. "Chill November" belongs to the Women's Conservation Art Association, Sarnia.

Hart House, University of Toronto, owns "The Pointers"; the University of Guelph, "The Drive." "A Northern Lake" (see p. 9) hangs presently in the Prime Minister's office, Queen's Park, Toronto.

The McMichael Conservation Collection at Kleinburg, Ontario, includes the largest permanent collection of Tom Thomson's work, more than forty sketches and two canvases in addition to some of his early work. Through the far-sighted efforts of Mr. and Mrs. Robert McMichael, Thomson's shack has been preserved. In 1962 it was moved from its site behind the Studio Building to the McMichael property where it serves as a museum for objects relating to Thomson's life and times.

At Owen Sound, the Tom Thomson Memorial Gallery and Museum of Fine Art houses a permanent collection of paintings by Thomson and other Canadian artists. The Gallery was founded in 1956 to act as a focal point for a regional art school and

exhibition centre in the area close to Thomson's boy-hood home.

Paintings by Tom Thomson may also be seen in the art galleries of Hamilton, Kitchener, Vancouver, and at Queen's University, Kingston; others are privately owned.

APPENDIX

These few trivial records may be justified only because firsthand memories of Thomson are so scarce. I can think of only three short accounts by friends who knew him well. They are: "A Landmark of Canadian Art" by J. E. H. MacDonald in the University of Toronto *Rebel,* November, 1917; "Tom Thomson: Painter of the North" by Dr. J. M. Mac-Callum, *Canadian Magazine,* March, 1918; and *Tom Thomson* by A. H. Robson in the Canadian Art Series (Ryerson Press, 1937). All are out of print long ago.

As nearly as I can remember, I first heard of Tom about 1910 when I was nine years old. My father, J. E. H. MacDonald, talked enthusiastically of him and I was always anxious to hear of anyone or anything connected with the woods. It was in winter, I think in 1912 or 1913, that he first came to our house to help my father with some work in commercial design that they hoped to finish by working all night. I hung around hoping to hear something about the North but can only recollect Tom smiling and quietly working. It is his quiet ways I remember best in thinking of him.

Later I often went to Tom's shack behind the Studio Building on Severn Street. This had been a little woodworking shop and it was repaired and lined with beaverboard, that forerunner of all the modern wallboards. Tom lived and worked there winters

until his death in 1917. Some unfinished picture usually stood on the easel and against the wall leaned, at various times, "The West Wind," "The Jack Pine," "The Pointers" and other less famous paintings. I was more interested in the canoe paddles and axe handles that Tom worked on in intervals of painting and some homemade trolling spoons and lures hanging on the wall. He made and carved his frames too. Seeing my interest in the axe handles he very characteristically gave me a couple and I have one of them still. If you admired his work at all, he was likely to give it to you.

He had a bunk and a little cast iron range for heat and cooking; the shack was clean and tidy. Sometimes he invited me to stay for meals and I remember well the woodsman's flourish with which he threw a handful of tea into the pot and mashed the potatoes with an empty bottle, adding what looked like half a pound of butter. While we ate he drummed his fingers on the table with great speed and vigor. I suppose he was anxious for me to go so that he could get to his work again. He must have felt me a nuisance in many ways, for often I tried to persuade him to come to Thornhill and go snowshoeing or shoot at a mark with our .22. He had always some excuse, even claiming that if he went away his fire would go out and his preserves would freeze. He had canned some of these from berries brought down from the North. One Fall he went hunting and brought us deer meat but later said he'd never do that again, "no more hunting."

Before living in this shack Tom worked at Grip Limited with my father and other young pioneers of Canadian Art. It was here that the manager had to remind his staff "he wasn't running an art school." When the Studio Building was opened, Tom worked for a time in the basement, then moved to the shack where he felt more at home. He was now encouraged

by Dr. MacCallum and L. S. Harris to give full time to painting. So began his wonderful development from small, dark and timid sketches to the rich colours and swift, confident painting of his last few years. This development was almost exactly paralleled by MacDonald's and their influence on one another can be clearly traced. Jackson, Harris, Lismer and Beatty also gave and received inspiration this way.

Thomson's work would be a fine study for some competent critic, but anyone attempting it should be familiar, not only with every phase of his work, but with the country too. He must know the trees, rocks, lakes, rivers, weather; have them in his bones. Only with all this knowledge, feeling and experience could such a study be made.... *"Criticism has its full worth ... only when it applies itself to subjects of which it possesses, through immediate contact, and from a long way back, the source, the surrounding facts and all the circumstances."*

Going in and out of Tom's place, I had an unappreciated chance to see his work in progress. But I preferred his outdoor sketches to his big paintings and still do.

Many stories and some myths have gathered round Tom's memory, some inconsistent with his character. One of these about his actions in a bank is given in F. S. Housser's book, *A Canadian Art Movement* (Macmillan, 1926) and elsewhere. My father always maintained this was false or exaggerated. He told me another incident, slight but more characteristic. One day Tom came in to work carrying a canoe paddle. He filled a photoengraver's tank with water and put it beside his chair, then without a word sat there gently paddling. At each stroke he gave the real canoeman's twist and his eye had a quiet gleam as if he saw the hills and shores of Canoe Lake.

One summer evening in 1917, my father returned from Toronto and came out to where we were picking black currants in that same Tangled Garden that made such a stir in the Art World. He could hardly speak as he told me that Tom had drowned up in the Park. I needn't give any details nor continue the regrettable speculations about his death. My father talked with all who knew anything about it and thought it over as carefully as anyone could. He always maintained Tom was accidentally drowned.

Soon after several of Tom's friends decided to put up a memorial cairn on the lake shore and after some discussion my father wrote a few words and designed a bronze plate, a really fine piece of lettering and design. Most of the work of building was planned and done by J. W. Beatty and his part in it should not be forgotten.

J. E. H. MacDonald acted as a sort of trustee of Tom's work. He designed a small die to identify the paintings as few were signed. By this time I was working with my father and helped in classifying and stamping the 300 or so sketches, Tom's life work. They were stacked in a tall set of shelves marked: Snow, Sunsets, Spring, Summer, Fall, and so on. I often regret my failure to study them but even so, some are in my memory still, especially one of a big burnt rampike, charred black and grey and covered with new snow. After my father died in 1932, I sent the die to the National Gallery where I suppose it still rests.

Thomson's work may be regarded as old stuff by many advanced artists and critics of the present but it maintains its steady place with those who still care for our Northern country, who like to see it nobly represented in painting and who still feel that those rivers, rocks and lakes are our home.

Thornhill, 1958 THOREAU MACDONALD,

87

1. Letter to Blodwen Davies from H. B. Jackson, April 29, 1931. (Public Archives, Ottawa)

2. The firm of *Grip* began in 1873 as producer of an illustrated newspaper. It was first in Canada to produce engravings on metal. When it ceased as a publication in 1884, Grip Ltd. continued operations as an engraving House, employing commercial artists to supplement the work of the mechanical department. See *Canadian Printer & Publisher,* May, 1967: "How Group of Seven, Canadian Press and other Canadian phenomena grew from one graphic arts company."

3. Harper, J. Russell, *Painting in Canada: a History* (University of Toronto Press, 1966).

4. An entry in Mark Robinson's Daily Journal for May 17, 1912, reads: We examined [fishing] licences of Thompson (*sic*) Party going to Crow River." And May 18: "Met the MacLaren Party and T. Thompson Party at evening train." (See note #11 below.)

5. Letter to Blodwen Davies from H. B. Jackson, May 25, 1930. (Public Archives, Ottawa)

6. A letter from a fishing companion, Leonard Mack, dated Toronto, March 16, 1913, refers to a trip taken the previous summer:
 Dear Mr. Thompson: It would be useless to attempt to apologize for not having written you before. I preferred not to do so immediately on my return from Algonquin Park as you would still have been in the bush and the letter would have been sometime in reaching you. I can hardly realize that the time has passed so quickly and that it is more than six months since Harry Bracken and I returned to Toronto. But I still have a very lively recollection of the trip and both Harry and myself feel very grateful to you for all that you did (and it was considerable) to add to the pleasures of the trip. The salmon [lake] trout which you will remember I brought out with me arrived here in fine condition and it was much appre-

ciated. I enclose a photo of myself holding the fish. I was under the impression that we took a photo of you fly casting from a rock on Crown Lake but perhaps we used your camera.

(Letter in possession of the Thomson family, Owen Sound, Ontario)

7. Thomson described this trip briefly in a letter to Dr. J. M. McRuer of Huntsville, Ontario. In spite of the "dump" and a great deal of rain, he reported, "we had a peach of a time as the Mississaga is considered the finest canoe trip in the world." The letter, undated, is in the McMichael Conservation Collection at Kleinburg, Ontario; the envelope is post-marked October 16, 1912.

Dr. McRuer's reply, dated November 1st, 1912, reads as follows:
You might have been drowned you devil and that was not the first time you were dumped. It was unfortunate that it had to happen so near the end of your trip. We would have been very glad to have seen you again this summer but hope you will stay much longer next year. Did you sit down on any more paint boards? (Letter in possession of the Thomson family, Owen Sound, Ontario)

8. MacCallum, James M. Typed manuscript. Public Records and Archives, Toronto, Ontario.

9. Northern Lake, $250. This is the amount shown in minutes of the Ontario Society of Artists, dated May 6, 1913. (Public Records and Archives, Toronto, Ontario) The Ontario Department of Education purchased several paintings from the O.S.A. exhibition for the Normal Schools of the province. "A Northern Lake" was sent to Ottawa where it remained for many years. In the late 1940s it was brought back to the Legislative Buildings, Toronto, and Premier Leslie Frost had it hung in his office.

10. The area originally set aside consisted of 1466 square miles. In 1914, this was increased and by 1968, the Park extended over approximately 3,000 square miles.

11. Lambert, Richard S. *Renewing Nature's Wealth* (Hunter-Rose Co., 1967), page 281.

12. Mark Robinson (1867-1955) knew Thomson as a frequent visitor to his shelter house at Joe Lake. The two men shared an interest in fishing and in the out-of-doors. Robinson was well known for his knowledge and skill as a woodsman and naturalist. He was often consulted by visiting naturalists; he provided specimens and materials requested by members of university staffs. He wrote frequently for his home newspaper in Barrie, Ontario and contributed articles for other newspapers and magazines. During his twenty-nine years on the Park staff, he served as Ranger, Chief Ranger, and Acting Superintendent at two different periods and was latterly a consultant under the administration formed in 1930.
Beginning in 1908, Robinson kept a Daily Journal recording the weather, wildlife observations, and events affecting the area of the Park assigned to him. In it he notes the arrivals and departures of visitors and gives other details of a routine nature. The Journals are in the possession of his daughter, Ottelyn Addison, at Richmond Hill, Ontario.

13. Little, R. P. "Some Recollections of Tom Thomson and Canoe Lake." *Culture*, XVI, Quebec (1955).

14. Transcript of tape recording made by Mark Robinson at Taylor Statten Camps, Canoe Lake, 1952, in conversation with Alex Edmison. (Collection of Mrs. Harry Ebbs, Toronto, Ontario)

15. Experienced guides earned about $4.00 a day and supplied cooking equipment; a second guide, if hired, earned half as much. Fire rangers were paid about $2.50 a day on a seasonal basis.
Guides paid $1.00 for a license which was renewable yearly. To obtain a license they had to be recommended by an inspector or game warden; they were responsible for the extinguishing of fires kindled by their party and they were required to report any violations of the game and fisheries law.

16. Letter to Blodwen Davies from Mrs. William (Minnie) Henry, February 2, 1931. (Public Archives, Ottawa)

17. Letter to Blodwen Davies from Mark Robinson, May 11, 1930. (Public Archives, Ottawa)

18. Letter to J. E. H. MacDonald from A. Y. Jackson, dated February 1914. (Thoreau MacDonald, Thornhill, Ontario)

19. Rowe was originally a typesetter but came to Mowat to work as a mill labourer for the Gilmour Lumber Company. After the company ceased operations he stayed on as a guide and general handyman. He shared a cabin with Larry (Lowrie) Dickson who worked part-time for Shannon Fraser. R. P. Little records that Larry was flattered when Arthur Lismer painted his shack in 1914 but when he heard that the painting ("The Guide's Home") had brought, or would bring, $400, he remarked, "I would gladly sell the cabin for less than that!"

20. Pringle, Gertrude, "Tom Thomson, The Man," *Saturday Night*, April 10, 1926.

21. See Appendix, p. 86

22. Letter to Blodwen Davies from H. B. Jackson, May 25, 1930. (Public Archives, Ottawa)

23. Letter to Dr. J. M. MacCallum, September 9, 1915. (National Gallery of Canada)

24. Brown, Florence Maud, *Breaking Barriers: Eric Brown and the National Gallery,* Publ. The Society for Art Publications, Paul Arthur, Editor; 1964.

25. Tom Wattie was a member of the Algonquin Park staff from 1909 to 1929, stationed at North Tea Lake. His family lived at South River, Ontario.

26. Jackson, A. Y., *A Painter's Country,* (Toronto, 1958).

27. Letter to Blodwen Davies from Mark Robinson, May 5, 1930. (Public Archives, Ottawa)

28. Letter to J. E. H. MacDonald, February 23, 1914. (Thoreau MacDonald, Thornhill, Ontario)

29. Lismer, Arthur, "Tom Thomson (1877-1917) Canadian Painter," *The Educational Record of the Province of Quebec,* Vol. LXXX, No. 3, July/Sept., 1954.

30. The late Vincent Massey's collection of Canadian art began with a group of Thomson's sketches purchased at the shack shortly after the artist's death. He described them as "red hot . . . (they) capture skies and landscapes instantaneously." (*Canadian Art,* March/April 1953)

31. MacCallum, J. M. "Tom Thomson: Painter of the North," *Canadian Magazine,* March, 1918.

32. Letter to Blodwen Davies from Ernest Freure, Guelph, Ontario, November 19, 1935. (Public Archives, Ottawa) Freure was a musician who met Thomson at Georgian Bay. "Tom was out in his canoe when a storm came up and he had to take refuge on my husband's island, where he was forced to stay for three days and they became good friends, visiting in each other's studios in Toronto." (Letter to Elizabeth Harwood from Mrs. Ernest Freure, Guelph, Ontario, April 29, 1969)

33. Letter to J. E. H. MacDonald, October 5, 1914. (Thoreau MacDonald, Thornhill, Ontario)

34. The letters quoted are from the MacCallum correspondence, National Gallery of Canada.

35. Letter to Blodwen Davies from Mrs. J. G. (Louise) Henry, March 11, 1931. (Public Archives, Ottawa)

36. Letter to Ottelyn Addison from Mrs. Edwin Thomas, Kish-Kaduk Lodge, Algonquin Park, February 16, 1956.

37. Letter to Blodwen Davies from Mrs. William (Minnie) Henry, February 2, 1931. (Public Archives, Ottawa)

38. Letter to J. E. H. MacDonald, July 22, 1915. (Thoreau MacDonald, Thornhill, Ontario)

39. Comfort, Charles, "Georgian Bay Legacy," *Canadian Art,* Vol. VIII, No. 3, Spring, 1951.

40. Letter from Truman W. Kidd to Miss Etta Tolchard, November, 1963, regarding Thomson's sketch "Autumn Scene" purchased in 1917 for Riverdale Collegiate, Toronto, at a cost of $15.00. (Letter in files of Riverdale Collegiate, Toronto)

41. Interview by William Arthur Deacon, *The Mail and Empire,* Toronto, 1936.

42. Ghent, Percy, "Tom Thomson at Island Camp, Round Lake, November, 1915," Toronto *Telegram,* December, 1949.

43. Harris, Lawren, *The Story of the Group of Seven* (Rous and Mann Press Limited, Toronto, 1964).

44. See Appendix, p. 85

45. Harris, Lawren, *The Story of the Group of Seven* (Rous and Mann Press Limited, Toronto, 1964).

46. Letter to J. D. Young, Toronto, dated "Sunday," [1966] from Mrs. Lawren Harris, Vancouver, B.C.

47. Letter to J. E. H. MacDonald, undated. (Thoreau Mac-Donald, Thornhill, Ontario)

48. Letter to Dr. James M. MacCallum, October 4, 1916. (National Gallery of Canada)

49. Letter to Miss A. L. Beatty, The Art Gallery, Toronto, May 14, 1937, from James MacCallum, M.D. (Art Gallery of Ontario, Toronto). Winifred Trainor (see #53 below) believed that "West Wind" was painted at Cedar Lake. She saw the sketch (to which Thomson had not given a name) and later recalled that in 1917 the artist was "grieved" over the canvas.

50. Letter to Blodwen Davies from Edward Godin, June 15, 1931. (Public Archives, Ottawa)
Arthur Heming(1870-1940) is perhaps best known for his books on northern Canada which he illustrated with his own paintings.

51. MacCallum, James M. "Tom Thomson: Painter of the North," *Canadian Magazine,* March, 1918.

52. Letter to J. E. H. MacDonald, July 22, 1915. (Thoreau MacDonald, Thornhill, Ontario)

53. It was rumoured around Mowat Lodge in 1916-17 (chiefly by Annie Fraser) that Tom Thomson and Winifred Trainor were to be married. A letter left carelessly lying on a dresser gave some substance to this rumour.
Many years after Thomson's death, Winifred Trainor rented the main floor of her house in Huntsville to a

93

high school teacher and his wife. When she showed them the living room, she remarked, "It isn't everyone who can say, 'I used the room that was painted by Tom Thomson'." The walls were an unusual shade of red, as if Thomson had mixed his own colours.

54. Letter to John Thomson, April 16, 1917. Thomson wrote few letters, even to his family. A gentle reproach is contained in his father's reply, dated April 19: "We were glad to get your letter and could take more. . . . Hope you have a successful summer." (Letters in possession of the Thomson family, Owen Sound, Ontario)

55. Letter to T. J. Harkness, Annan, Ontario, undated but presumed to have been written in April, 1917. (Thomson family, Owen Sound, Ontario)

56. Letter to Dr. James M. MacCallum, April 21, 1917. (National Gallery of Canada)

57. Letter to Dr. James M. MacCallum, May 8, 1917. (National Gallery of Canada)

58. Curtis Williamson (1867-1944) worked at the Studio Building while Thomson was there. In 1917 he painted a portrait of Dr. MacCallum entitled "A Cynic."

59. Letter to Dr. James M. MacCallum, July 7, 1917. (National Gallery of Canada)

60. The Blechers were summer residents from Buffalo, N.Y., who owned the largest of the three houses on the shoreline near Mowat Lodge.
Mark Robinson assumed that if Thomson had met with an accident, it would be on land; he considered it more important to search for him lying injured in the bush than to drag for a dead body.

61. Feeling that there was little he could do at this time, George Thomson left. He returned to Mowat Lodge on July 19 to collect Thomson's paintings and other possessions.

62. Dr. G. W. Howland was spending his holidays at the Taylor Statten cabin on Little Wapomeo Island. Edwin Colson was the proprietor of the Hotel Algonquin.

63. An account of the death of Tom Thomson is given by the late Mrs. E. Thomas in a letter dated February 16, 1956 (see note #36 above) :

We saw him pass the Station Sunday noon with Shan Fraser, went pas[t] the Section house, hot sultry day fine rain. that was July 8, 1917. We spoke to them on their return. had left the canoe Joe Lake Creek. he was drowned the same afternoon. Martin Bletcher (*sic*) saw the canoe floating he went out and took it to Fraser's. no one heard anything till Mr. Fraser came down Monday morning with the mail he wanted to send a telegram to Owen Sound. then he told me that Tom T. canoe was found. they feared he was drowned but your Dad said no he his not drowned he his away in the Bush painting his canoe got away on him your Dad knew his habits. Jack was with your Dad just a little fellow those days: they hunted the woods no Tom T. If I remember right it was Dr. Howland found him the following Monday like nine days after. . . .

64. Letter to Dr. James MacCallum, from Margaret Thomson (Tweedale), August 2, 1917. (Colgate Collection, Public Records and Archives of Ontario, Toronto)

65. Letters in the possession of Thoreau MacDonald, Thornhill, Ontario.

66. "The Canadian Algonquin School," *Mail and Empire,* Toronto, February 21, 1920.

67. Brown, Florence Maud, *Breaking Barriers: Eric Brown and the National Gallery.* Publ. The Society for Art Publications, Paul Arthur, Editor; 1964.

68. *Ibid.*

69. MacCallum, J. M. *Tom Thomson: Painter of the North:* Catalogue and Loan Exhibition of Works of Tom Thomson, March, 1937. Mellors Galleries, Toronto.

70. Housser, F. B., *A Canadian Art Movement,* p. 117 (Macmillan, 1926).

71. Letter addressed but not mailed to F. B. Housser, December 20, 1926. (Thoreau MacDonald, Thornhill, Ontario)

SOURCE MATERIALS

Conversations with

Mrs. W. M. Tweedale, Mr. and Mrs. Fraser Thomson, George M. Thomson, Mrs. F. E. Fisk and Mr. and Mrs. G. Henry (members of the Thomson family); Miss P. Austin, A. J. Casson, Mrs. Robert Crombie, Misses I. and K. Dickson, Dr. and Mrs. Harry Ebbs, J. Alex Edmison, Miss Mary Little, Dr. H. Mortimer Lamb, Norman Massey, Thoreau MacDonald, Mr. and Mrs. R. McMichael, The Honourable J. C. McRuer, Mr. and Mrs. Gordon Wattie and J. D. Young.

Letters

The MacCallum Correspondence in the National Gallery, Ottawa; J. E. H. MacDonald's letters in possession of Thoreau MacDonald, Thornhill, Ontario; Letters to Blodwen Davies regarding Tom Thomson, Public Archives of Canada, Ottawa.

Journals and Notes

of Mark Robinson (in possession of Ottelyn Addison, Richmond Hill, Ontario); taped recollections of Mark Robinson in conversation with J. Alex Edmison (Collection, Mrs. Harry Ebbs, Toronto).

Sessional Papers

(No. 22)—1894. Reports on Algonquin Provincial Park; (No. 3)—Annual Report of the Minister of Lands and Forests, 1914. Legislative Library, Parliament Buildings, Toronto, Ontario.

Catalogues, Brochures and Pamphlets

Fine Arts Department, Central Reference Library, Toronto; Archives of Ontario Gallery of Art, Toronto; National Gallery, Ottawa; Provincial Archives of Ontario, Toronto; The McMichael Conservation Collection, Kleinburg, Ontario; The Tom Thomson Memorial Gallery and Museum of Fine Art, Owen Sound, Ontario.

BROWN, FLORENCE MAUD *Breaking Barriers: Eric Brown and the National Gallery.* The Society for Art Publications, 1964.

COLGATE, WILLIAM *Canadian Art, Its Origin and Development.* Toronto: Ryerson, 1943.

DAVIES, BLODWEN *Paddle and Palette, The Story of Tom Thomson.* Toronto: Ryerson, 1930.
A Study of Tom Thomson. Printed at the Discus Press, 1935.

EDWARDS, C. A. M. *Taylor Statten, A Biography.* Toronto: Ryerson, 1960.

HARPER, J. RUSSELL *Painting in Canada: A History.* University of Toronto Press, 1966.

HARRIS, LAWREN *The Story of the Group of Seven.* Toronto: Rous & Mann, 1964.

HOUSSER, F. B. *A Canadian Art Movement.* Toronto: Macmillan, 1926.

HUBBARD, R. H. *Tom Thomson.* The Gallery of Canadian Art: 2. Toronto: McClelland & Stewart, 1962.

JACKSON, A. Y. *A Painter's Country: The Autobiography of A. Y. Jackson.* Toronto: Clarke, Irwin & Company Limited, 1958.

LAMB, H. MORTIMER "Studio Talk: Tom Thomson," *Studio,* LXXVII (1919), pp. 119-126.

LISMER, ARTHUR "Tom Thomson (1877-1917), Canadian Painter." *The Educational Record of the Province of Quebec,* Vol. LXXX, No. 3, July/Sept., 1954.

LITTLE, R. P. "Some Recollections of Tom Thomson and Canoe Lake," *Culture* XVI (1955), pp. 200-208.

MacCALLUM, J. M. "Tom Thomson: Painter of the North," *Canadian Magazine* (1918), pp. 375-385.

MacDONALD, J. E. H. "A Landmark of Canadian Art," *The Rebel,* Vol. II (November, 1917).

McLEISH, J. A. B.	*September Gale: A Study of Arthur Lismer.* Toronto and Vancouver, 1955.
ROBSON, ALBERT H.	*Canadian Landscape Painters.* Toronto: Ryerson, 1932.
	Tom Thomson. Canadian Art Series. Toronto: Ryerson, 1937.
SAUNDERS, AUDREY	*Algonquin Story.* Ontario Department of Lands and Forests, Toronto, 1947.

PHOTOGRAPHIC CREDITS

Numbers refer to page in text.

Thomson Family: 2, 3, 5, 15, 20, 23, 63.
Mark Robinson Collection (photographs prepared by W. D. Addison): 18, 23, 29, 34, 37, 58, 68, 72, 73, 74.
Thoreau MacDonald: 7, 21.
National Gallery of Canada, Ottawa: (i) frontispiece.
Tom Thomson Memorial Gallery and Museum of Fine Art, Owen Sound: 19.
Ontario Department of Lands and Forests, Toronto: 34.
Ontario Department of Energy and Resources Management, Toronto: 48.
Addison, Edward: 45.
Crombie, Mrs. R.: 61.
Dickson, Misses I. and K.: 34.
Edmison, J. Alex: 10, 13.
Little, Miss Mary: 12, 14, 37, 58.
Pierce, Bruce: 49.
Wattie, G.: 24.
 Paintings from the Ontario Gallery of Art, Toronto: 8, 11, 56.
 Private Collections: 4 and 5 (photographed by Colin S. Farmer), 7, 56, 67.
 Map: (ii) Peter M. Addison.

98